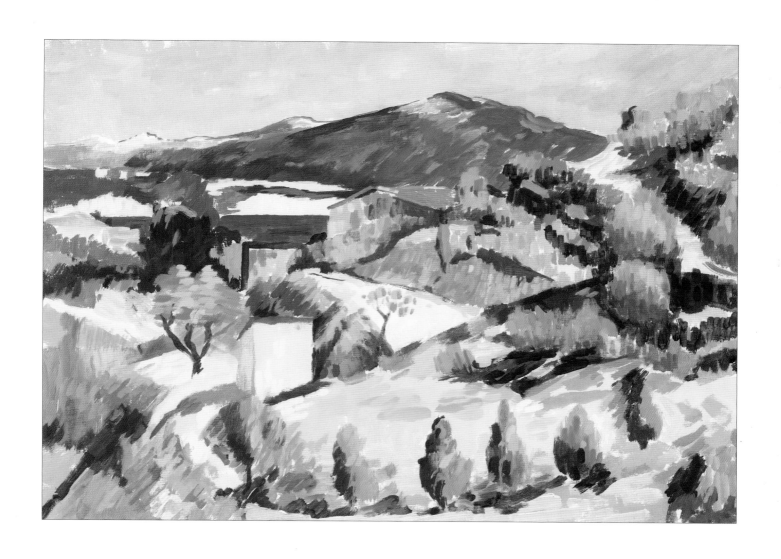

READY TO PAINT

Cézanne

Michael Sanders

SEARCH PRESS

First published in Great Britain 2010

Search Press Limited
Wellwood, North Farm Road,
Tunbridge Wells, Kent TN2 3DR

ISBN: 978-1-84448-575-8

Suppliers
If you have any difficulty obtaining any of the materials and equipment
mentioned in this book, please visit the Search Press website:
www.searchpress.com

Publisher's note
All the step-by-step photographs in this book feature the author,
Michael Sanders, demonstrating acrylic painting. No models have
been used.

**Please note: when removing the perforated sheets of tracing paper
from the book, score them first, then carefully pull out each sheet.**

Page 1
Mountains in Provence
42 x 29.5cm (16½ x 11¾in)

*This version of Cézanne's original appears as a step-by-step project
on pages 34–45.*

Printed in China

Dedication

I would like to dedicate this book to you, dear reader.
If you are reading this, you are probably interested in
art. That means you appreciate paintings, creativity,
colour, and all the fine things of life. So, use the book,
have fun doing the paintings, and consider yourself
an artist; the world needs more of us.

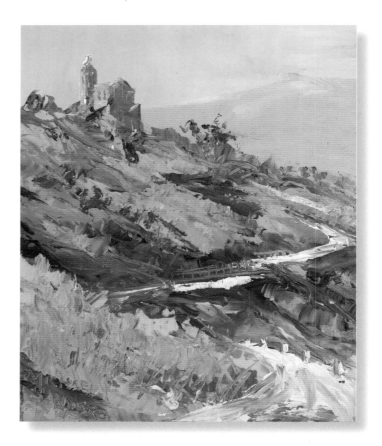

Acknowledgements

It is always a pleasure to work with everyone at
Search Press, especially Roz, Sophie and Juan. Thanks
also to Roddy and Gavin for the photography.

Above
St Pere de Rodes, Spain
20.5 x 25.5cm (8 x 10in)

*This was painted as a demonstration for one of my painting holiday
groups. It is a favourite destination of mine, high in the hills close
to the French border in Catalonia, Spain. I had been discussing the
Provençal colours used by Cézanne and did this to show how the
combination of warm oranges and ochres with strong greens can
evoke a hot landscape. There is very little detail, and most of the
texture has been left quite rough so that the surface of the painting
is an interesting thing in its own right. The group seemed to think it
looked like Cézanne's style, so I was quite pleased!*

Contents

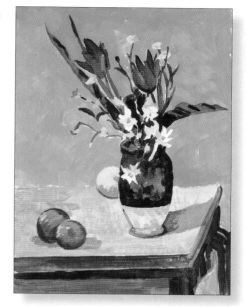

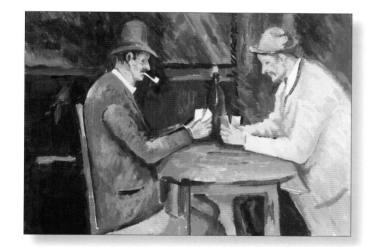

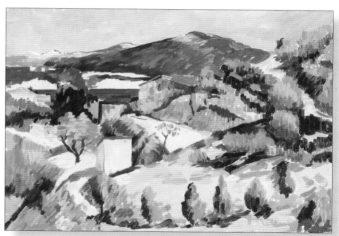

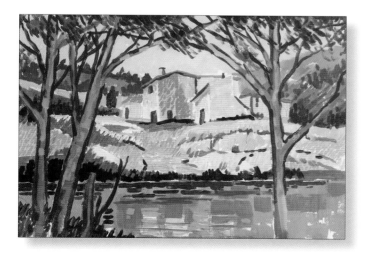

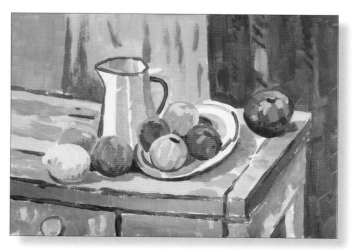

Introduction

Every country in the world has collections of art; a visual tradition that allows us to see how artists from the past worked, and what inspired them. In earlier times, anyone wanting to learn to paint would have studied these 'Old Masters' in galleries, and often their art education would have included making copies of them. Now, you can learn like this too. You don't even need to be able to draw!

In this book, you will find tracings of some of Cézanne's most famous paintings. The step-by-step examples will show you clearly how the brush strokes are applied to build up the 'look' that is a feature of his work. I have also included some of my own paintings using his style, and there are tracings for these too.

Paul Cézanne is recognised as one of the most influential artists of all time, and I enjoyed researching his style and techniques, especially as I once lived in Provence in the South of France, close to the area where he worked for most of his life. In his landscapes, the colours he used and his way of applying them are very evocative of the warmth and vibrancy of that beautiful mountainous countryside.

Like most of the 'Old Masters', Cézanne mainly painted with oil paint. However, oils can be smelly and messy to use, so we use acrylics for our versions; they are quick drying, odourless, and easy to use. Bear in mind that acrylics dry quickly. Because of this, always make sure you have a couple of jars of water; use one for dipping into if you need to dilute the paint, and the other to pop your brushes into when not in use. Never let paint dry in the brushes; they could be ruined if you do. Rinse them clean and dry them with some kitchen paper before using them again. Don't make the paint too runny; most of the techniques use 'stiff' paint applied fairly thickly.

It is worth remembering that acrylics dry slightly darker, so when mixing colours, make them slightly lighter than shown. While researching for this book, I looked at several books on Cézanne, and noticed that each one showed the same paintings with slightly different colours. So, don't worry if your paintings are slightly different to mine; unless you own the original Cézanne, you will never know the difference!

Dartmoor, Passing Storm

During the time I was researching techniques used by Cézanne, I went out on to the moors and painted this image. It was not meant to be painted in any particular style, but I suppose, subconsciously, I must have absorbed the idea of separate brush strokes and touches of strong colour. It was a very windy day. I managed to park the car where I could get the view I wanted, but the weather was so blustery that I had to tie the easel to the car to stop it blowing away! The strong direction of each line, and the touches of dark red or blue here and there, have created an interesting composition. There is a bonus tracing of this painting at the front of the book, in case you want to try it when you have worked on the other projects. I will leave you to decide for yourself on the best brushes to use, and the projects in the book should familiarise you with Cézanne's colours. I hope you enjoy doing this as much as I did, but I bet you don't get as cold!

TRACING

1

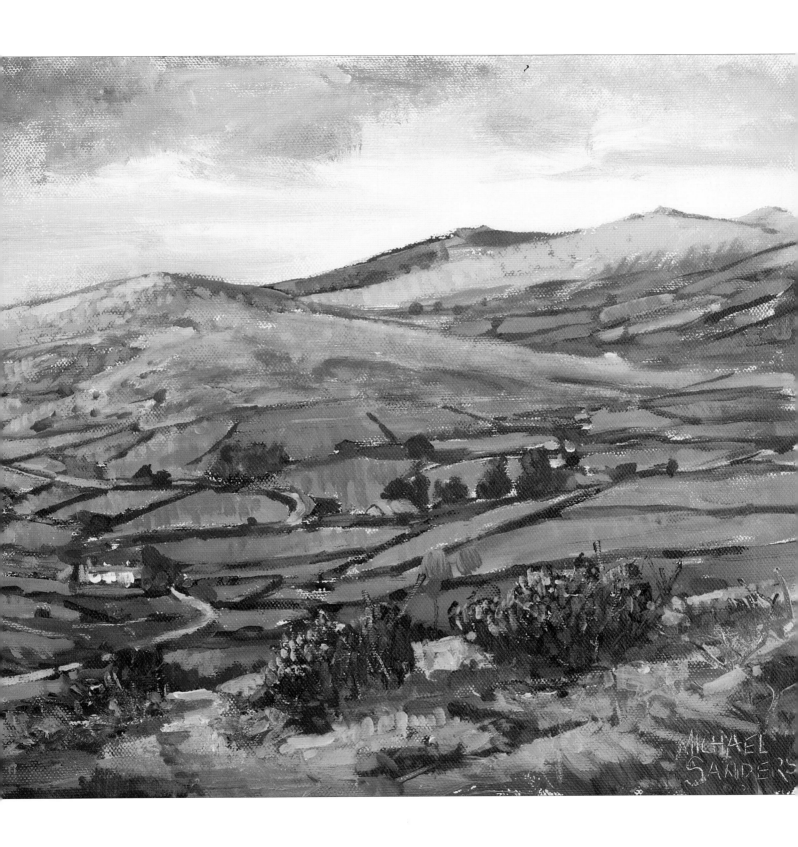

Cézanne

Paul Cézanne (1839–1906) is widely regarded as one of the most influential artists of any generation. Although not really an Impressionist, he has been celebrated as the greatest artist of that era, whose work laid the foundations that others, such as Picasso, would follow, and as the 'Father of Modern Art'. Closely involved with the Impressionists as he initially was, and although he admired the colour and life that they introduced into painting, Cézanne was nevertheless uneasy with the speedy execution they used in order to capture a 'brief moment in time', preferring a more considered build-up towards the finished picture in order to impart a feeling of permanence. He wanted to achieve the stability and 'firmness' found in more classical art, and is reported to have said, in later life, 'I wanted to make of Impressionism something durable, like the art found in museums'.

For an artist of such uniqueness he seems to have had a remarkably uneventful life, spending much of it in deliberate isolation and obscurity. He was never poverty-stricken (although money was not always plentiful), nor was he bohemian, or outrageously self-publicising, unlike some of his contemporaries. He never courted glamorous exposure or fashion, and never associated himself with any particular artistic group for very long. His struggles were personal ones, like his relationship with (and fear of) his unsympathetic father, and his search for 'certainty' in his work.

Born in Aix-en-Provence, twenty miles north of Marseilles in the South of France, into a well-to-do middle class banking family, he grew up in the company of such creative young men as Emile Zola and Baptistin Baille, spending time communing with nature and writing. Ironically, Zola, who would go on to become one of the most celebrated writers of his age, was the one who showed artistic promise, winning most of the prizes for drawing at school, while the young Paul Cézanne poured his concentration into becoming a poet. His vocation as an artist appeared slowly, and was not encouraged at home, although he attended the free drawing academy nearby.

His father, a self-made businessman, was not particularly encouraging. The family wanted him to have a good education that would permit him to move into a dependable career, rather than the insecurity of an artistic life, so Paul was sent to study at university in Aix. Zola had gone to Paris, and, after two years studying law, Cézanne was becoming more determined to throw off the shackles of provincial life and join him. Eventually his father relented reluctantly and, in 1861, aged twenty-two, Cézanne found himself in Paris with a modest allowance, ready to begin his chosen career. It proved a disastrous false start; within a few months he was back at Aix, working as an assistant in his father's office. The reasons were partly his temperament – he was painfully shy but easily irritated – and partly his shock at the Parisian avant-garde attitude to art and life, which conflicted with his conventional ideas at the time.

For at least the next ten years he appears to have drifted restlessly from studio to studio, moving between Paris and Aix. Suffering rejection from both the Salon in Paris and his peers, he was defended in print by his journalist friend Zola, and found himself associating with a group of artists who were able to offer him some encouragement; the future Impressionists. Artists such as Monet, Renoir and Pissarro were fundamental in shaping Cézanne's belief in the importance of nature as a direct influence. They became close friends, and he and Pissarro would paint out of doors around Pontoise, near Paris, their easels side by side, although their techniques and attitude were very different.

Cézanne was still dependent on his unsympathetic father, with a very meagre allowance to sustain him, and things became more complicated when he became involved with a model, Hortense. Their liaison, and eventually their son, had to be kept secret from the family at Aix.

Even well into his thirties, Cézanne was apparently fearful of his father's opinion.

Despite his early connection with artists who would form the nucleus of Impressionism, Cézanne wanted more structure and stability in his work. He exhibited in their first exhibition in 1874, and again in 1877, but met with almost universal abuse from critics and public alike. During these years, his dogged determination and willpower developed, and it may have been the painful criticism of his work that pushed him into a more secretive and reclusive lifestyle. He retreated back to the south, and on his rare visits to Paris, tended to avoid the artistic community, so that within a few years he was almost completely forgotten by most of them.

It was during those years of 'exile' that Cézanne developed his distinctive and recognisable style. He was quite original in his approach to painting landscape, pushing far beyond photographic realism and putting together patterns of visible brush strokes, so that the painting became a subject in its own right, and not merely a copy of a view. Equally original is the absence, often, of a single focal point, with the entire painting surface given equal attention and emphasis. Another genre that he made his own was the still life, and here he appears to exercise complete control; many of his objects appear to flout the laws of perspective and other conventions; he does with them what he pleases, with an almost mosaic-like pattern of colours and visible brush strokes.

In 1890, Cézanne exhibited in Brussels, and attracted considerable attention. This led to his first major solo exhibition, with the young art dealer Ambroise Vollard. From this period his true worth and genius began to be recognised by the art world, and his personal life seems to have become one of modest tranquillity, untroubled by money worries or family disputes (his father having died and left him comfortably wealthy) with his son Paul acting as intermediary and agent between the artist in Aix and the galleries in Paris and elsewhere. The only major upset was the severing of his lifelong friendship with the writer Emile Zola. The portrayal of an 'artist failure' in Zola's novel *The Masterpiece* resembled Cézanne closely enough to cause him deep hurt.

In old age, deteriorating health (he was diabetic) often left him complaining of reduced energy, yet he continued to paint in the open air. The immediate local area offered Cézanne a range of motifs to which he would return time and time again. The quarry at Bibemus, the Chateau Noir and Mont Sainte Victoire are all images that he made his own. In 1902 he had a studio built on a hill with peaceful views of Mont Sainte Victoire and Aix, so his beloved motifs were always available.

In October 1906, Cézanne was caught in a violent thunderstorm while painting, and he contracted pneumonia and died. He left a legacy that has inspired generations of artists, believing that a painting should be an independent creation and not just a copy of reality. Because of this shift in perception he made possible most of the great art movements that followed. He is, rightly, described as the 'artists' artist'.

Self Portrait

This was painted in 1880. The strong brush strokes show the planes of the face, and the diagonal background pattern helps to lead the eye into the image from the side. The painting simultaneously evokes a sense of self-confidence and a strong personality, but also privacy and a wariness of strangers.

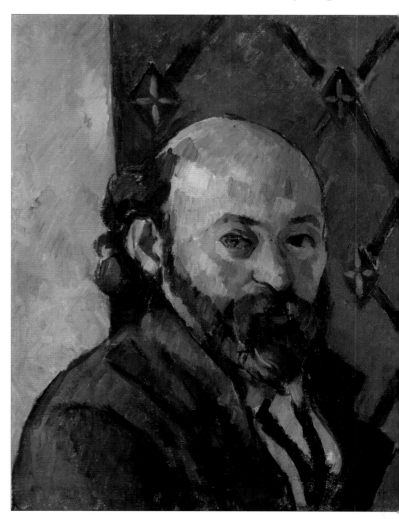

Materials

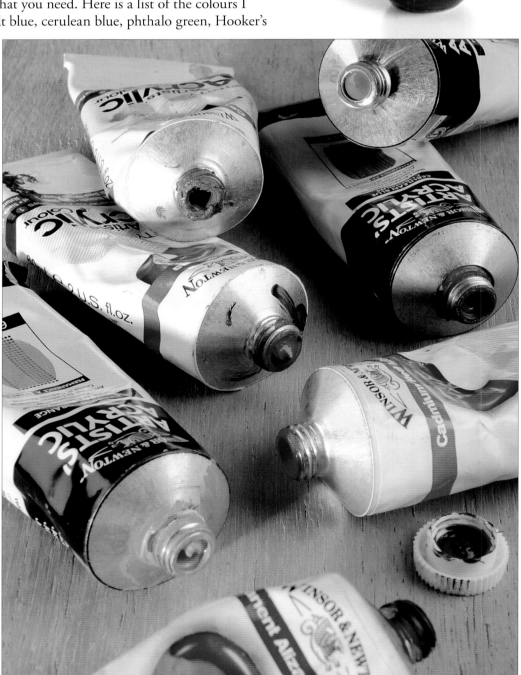

Paints

Cézanne painted most of his important work in oil paint, although he used watercolour in his later years. Because oils are so messy, and dry slowly, they are best avoided until you have had some practice. Acrylics are easier to use, and they dry quickly, so you can paint over any mistakes or put one colour next to another without worrying about it. Acrylics are also safer, because there is no need for solvents like turpentine; all you need is water. The best way to get good results is with good quality paint, so avoid buying paints in sets from stationers or market stalls, where the quality may not be very good. Go to an art shop or get a catalogue from an art materials supplier or online, and buy tubes of the colours that you need. Here is a list of the colours I have used: phthalo blue, cobalt blue, cerulean blue, phthalo green, Hooker's green, titanium white, burnt umber, burnt sienna, alizarin crimson, cadmium red, cadmium orange, cadmium yellow, lemon yellow and Naples yellow.

Acrylic paints in tubes.

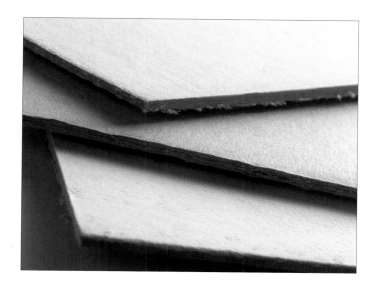

Surfaces

One of the benefits of acrylics is that you can use almost any non-shiny surface to paint on as long as it is not greasy. I use a thick cardboard known as grey board, which is available from art shops or framers. I use an old household paintbrush to prime the boards with an acrylic primer called gesso. You can use white emulsion paint if you want to, but you will need to apply more coats than with gesso. I paint the boards, then cut them to the size required with a craft knife. Hardboard can be used, or MDF, as long as it is primed with an acrylic primer. You can buy canvas boards, which have a texture like real canvases, but they are more expensive than the other types of board.

Brushes

Cézanne used oil painting brushes for his major work, and the ones available today are much the same shapes as he would have used. For durability and cost, I prefer the synthetic hog bristle brushes rather than 'real' hog brushes; they hold their shape better. Every major art materials manufacturer makes brushes, but unfortunately they have never standardised the size system. A number 12 in one make could be a number 6 in another. To avoid confusion, I have drawn the outlines of the brushes I have used. Simply take this book to the art shop and compare the size with my outline.

Brushes for painting in acrylics and oils are harder and stronger than those for watercolour. I have used mainly flat brushes for all these paintings: a small, medium and large one. Add a round to these, the size shown, and you will have enough.

As with paints, avoid buying cheap packs in stationers or market stalls; you will never create your masterpiece with poor brushes!

When using them, try to 'spoon' the paint up, rather than dipping. With a bit of practice you will soon get used to it. Don't forget; always dip the brush in water as soon as you have finished using it, and wash it thoroughly before putting it away.

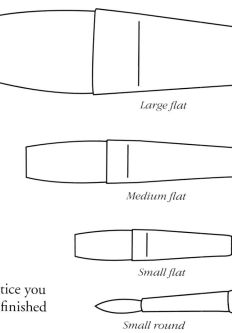

Large flat

Medium flat

Small flat

Small round

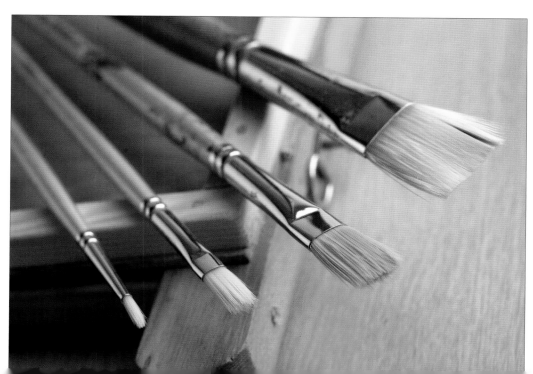

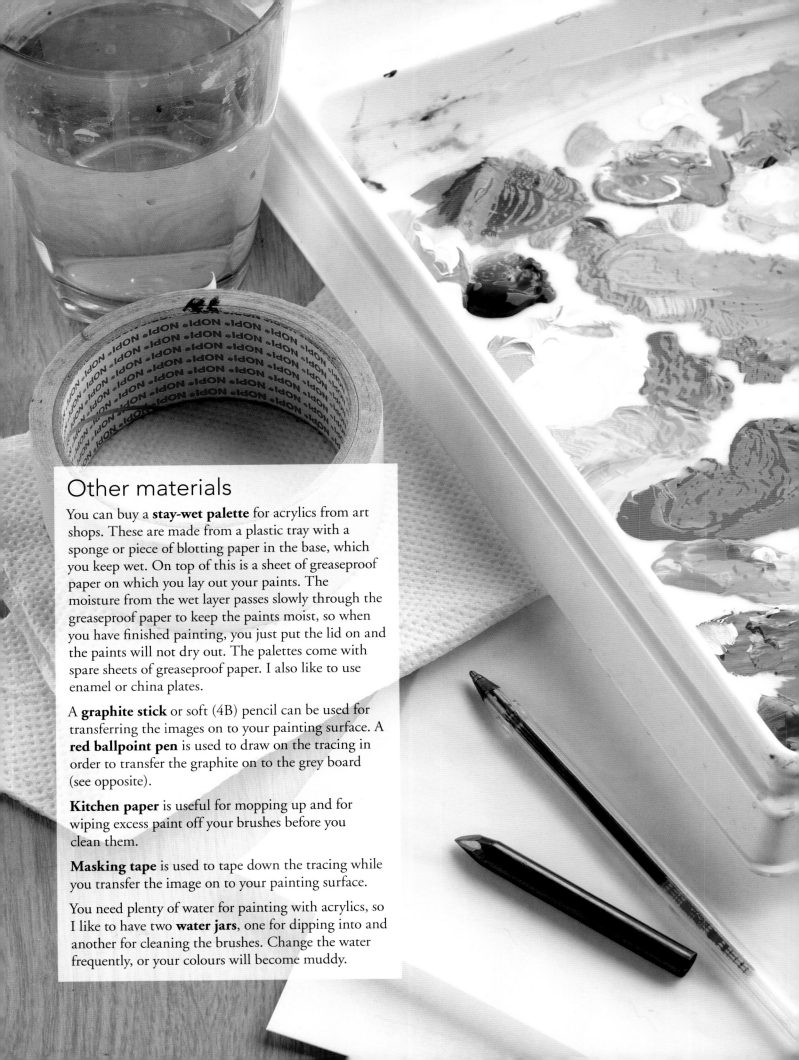

Other materials

You can buy a **stay-wet palette** for acrylics from art shops. These are made from a plastic tray with a sponge or piece of blotting paper in the base, which you keep wet. On top of this is a sheet of greaseproof paper on which you lay out your paints. The moisture from the wet layer passes slowly through the greaseproof paper to keep the paints moist, so when you have finished painting, you just put the lid on and the paints will not dry out. The palettes come with spare sheets of greaseproof paper. I also like to use enamel or china plates.

A **graphite stick** or soft (4B) pencil can be used for transferring the images on to your painting surface. A **red ballpoint pen** is used to draw on the tracing in order to transfer the graphite on to the grey board (see opposite).

Kitchen paper is useful for mopping up and for wiping excess paint off your brushes before you clean them.

Masking tape is used to tape down the tracing while you transfer the image on to your painting surface.

You need plenty of water for painting with acrylics, so I like to have two **water jars**, one for dipping into and another for cleaning the brushes. Change the water frequently, or your colours will become muddy.

Transferring the image

It could not be easier to pull out a tracing from the front of this book and transfer the image on to your painting surface.

1 Scribble over the reverse of the tracing using a 4B pencil or a graphite stick, as shown here.

2 Turn the tracing right side up and tape it down with masking tape on your painting surface. Use a ballpoint pen to go over the lines of the tracing. I have used red ballpoint pen as this shows up better.

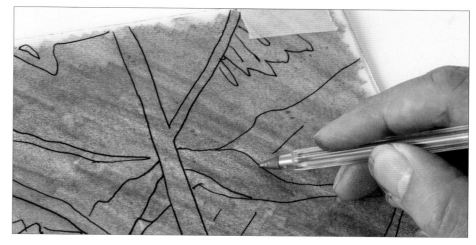

3 Lift up the tracing and you will see that the image has transferred to the painting surface.

Vase of Tulips

Cézanne painted fewer flower studies than still lifes, for a very prosaic reason; he worked slowly and methodically, often gazing for long periods before making a single brush stroke, so the flowers would begin to wilt before he had even started on them. When he did paint them, the technique was more direct, and with a more fluid, elongated brush stroke, rather than the shorter strokes he uses in other subjects. This image uses the contrast between solid masses of colour in the pot and the light touches of paint that denote the blooms. Red and green work well together, and this 'complementary' colour combination is used here to good effect.

You will need

Grey board primed with white gesso

Colours: phthalo blue, phthalo green, titanium white, burnt umber, cerulean blue, alizarin crimson, cadmium red, cadmium yellow, cadmium orange

Hog brushes: large flat, medium flat, small flat, small round

Tip

When painting the thin wispy lines that appear here and there, you will find it easier to dilute the paint slightly to get more 'flow'. Remember, as you mix colours, that the acrylics will dry slightly darker than when wet.

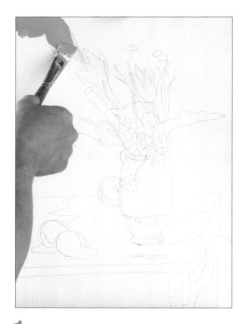

1 Mix phthalo blue, phthalo green and white and dilute it with a little water. Use a large flat brush to block in the background. It does not matter if the background looks streaky.

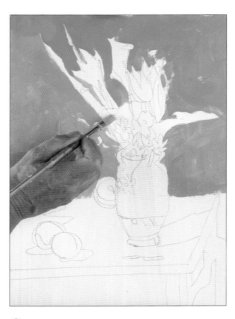

2 Use the medium flat brush to paint round the finer details of the flowers.

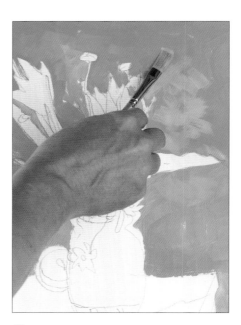

3 Add a few light touches of titanium white to create a streaky effect.

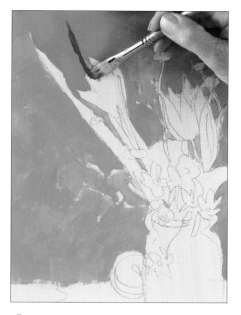

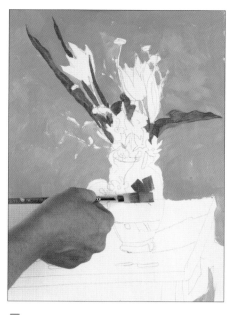

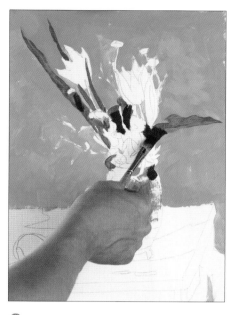

4 Mix phthalo green with a little water and use the edge of the brush to block in the leaves, still using the medium flat brush.

5 Paint the vase with the same colour, so that it harmonises.

6 Mix phthalo green with burnt umber and use diagonal brush strokes to paint the darker parts of the leaves, going over the previous green.

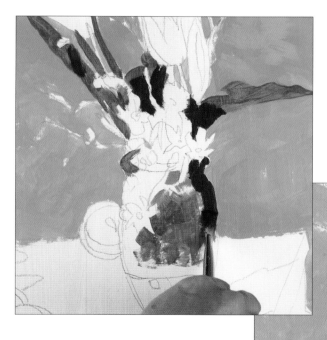

7 Paint the rim and shaded side of the vase with the same dark green mix.

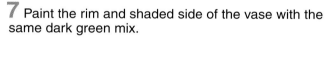

8 Apply more of the dark green to the front of the vase with loose brush strokes, lightly dragging the colour over the surface and letting the lighter green show through.

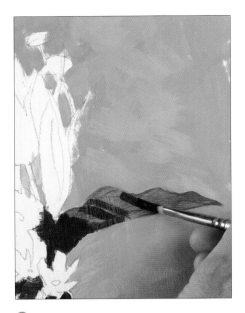

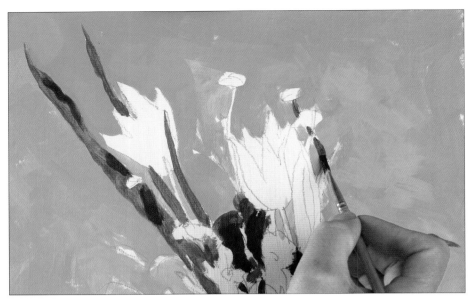

9 Change to the small flat brush and use the same dark green mix of burnt umber and phthalo green to paint short, diagonal brush strokes. Leave them as unblended single strokes.

10 Continue with the same short, directional brush strokes, indicating the darker areas of the leaves and the stems.

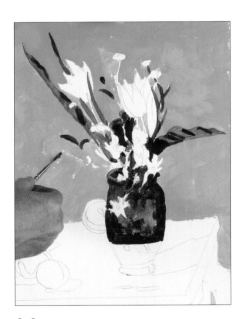

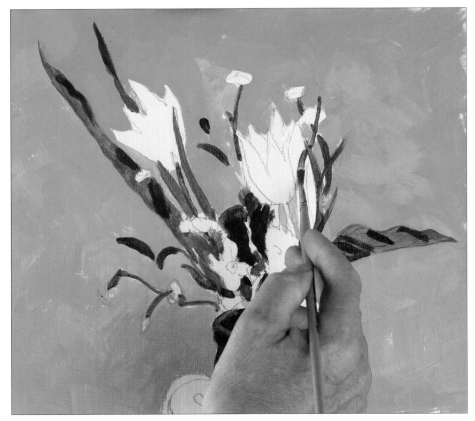

11 Add more leaves and a bud on the left-hand side with the same mix and the edge of the small flat brush.

12 Use a small round bristle brush to add a tiny bit of titanium white to the dark green areas, creating fine lines.

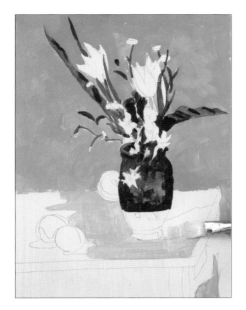

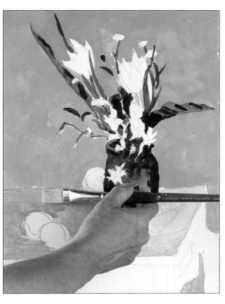

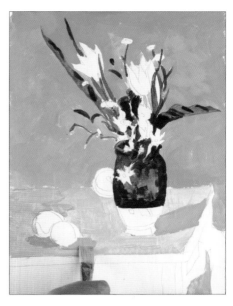

13 Use the large flat brush to block in the table with a slightly diluted mix of titanium white, cerulean blue and burnt umber. Paint with loose brush strokes, as the effect should not be too neat and tidy.

14 Add alizarin crimson to the grey table mix to give it a purple tinge and paint this in on the left-hand side.

15 Add more phthalo blue to the mix to make a blue-grey and paint the shadows of the vase and of the fruit on the left.

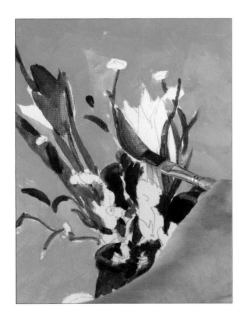

16 Make a slightly diluted mix of alizarin crimson and cadmium red and paint the simpler shapes of the tulips with the medium flat brush.

17 Paint the same colour on the bottom left-hand side of the fruit on the left.

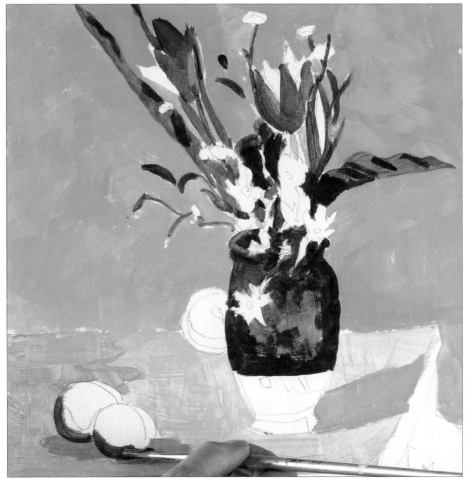

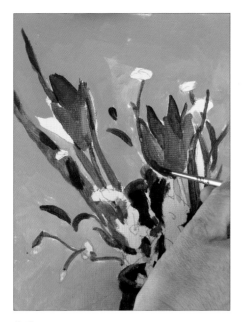

18 Use the small round brush and a mix of alizarin crimson and burnt umber to paint the darker tones of the tulips.

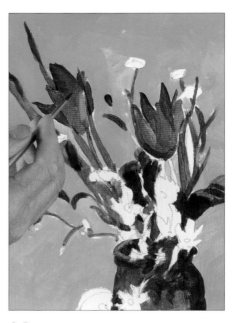

19 Continue painting the left-hand tulip with the darker mix. Paint little diagonal touches of colour.

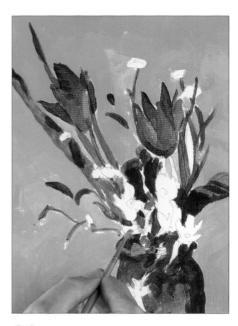

20 Paint the little buds around the top of the vase with a pinkish mix of cadmium red and white.

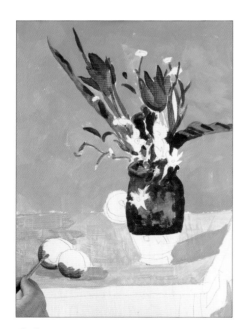

21 Paint the same pinkish mix on part of the fruit with short, diagonal brush strokes.

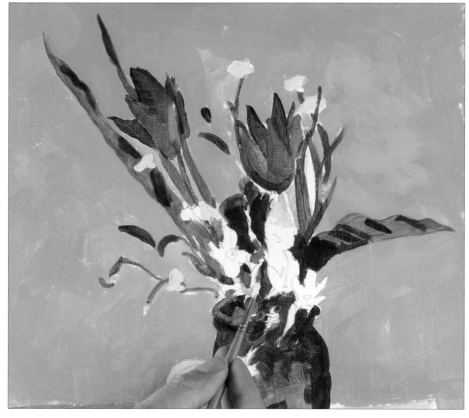

22 Mix cadmium yellow and white and paint the yellow flowers.

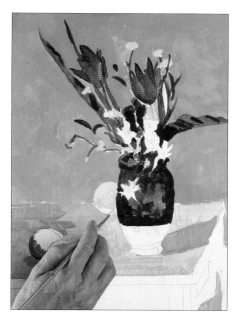

23 Use the same yellow to paint the top of the yellow fruit in the background. Add a touch of cadmium red with diagonal brush strokes to paint the lower part of the fruit.

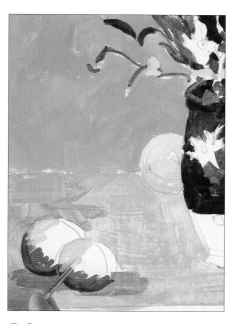

24 Apply the same deep yellow colour to the foreground apples, using diagonal brush strokes.

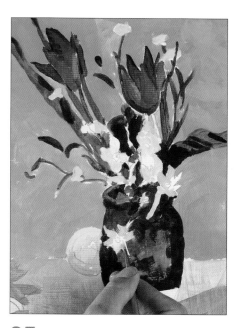

25 Mix titanium white and a tiny bit of cerulean blue to paint the white flowers. Your brush strokes should go towards the centres of the flowers.

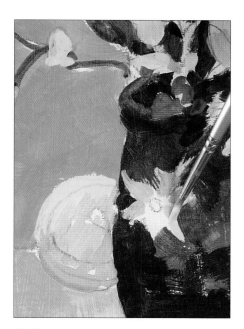

26 Paint pure titanium white in towards the centre of each flower and add little touches on the petals, both outside and inside the flower.

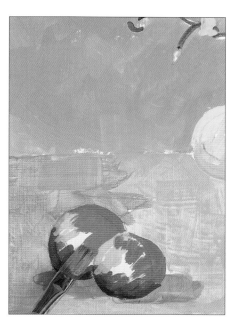

27 Paint the upper parts of the foreground apples with cadmium orange with touches of cadmium red, titanium white and burnt umber. Use diagonal strokes of the medium flat brush.

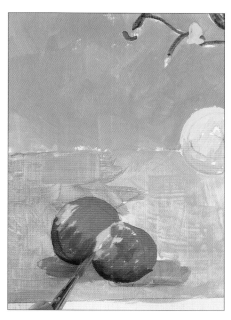

28 Add more burnt umber and red to the mix and paint diagonal strokes in the centres of the apples, then darken the undersides.

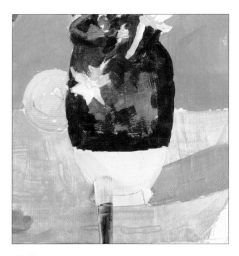

29 Make a very pale grey from titanium white with a little cerulean blue and burnt umber, and paint the base of the vase with big, bold strokes of the medium flat brush.

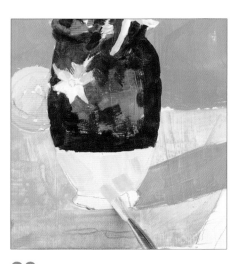

30 Add more cerulean and burnt umber to the mix and paint diagonal brush strokes on the shadowed side of the vase.

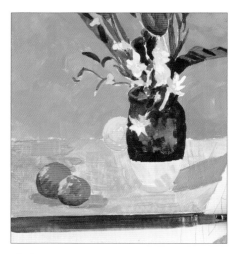

31 Mix burnt umber with a touch of titanium white to make a dark brown and block in the edge of the table.

32 Add an orange mix of cadmium red and cadmium yellow, and dilute the mix a little to paint the lighter right-hand edge of the table.

33 Add more cadmium yellow to the mix to paint the shaded parts of the background fruit.

34 Work around the base of the vase with the small round brush and a mix of burnt umber and cerulean blue.

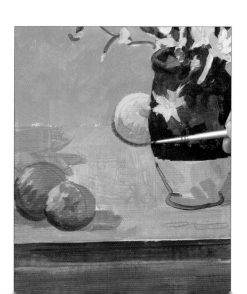

35 Paint the same dark line to define the bases of the foreground and background fruit.

36 Mix a very dark green from burnt umber and phthalo green and use the small round brush to fill in bits of foliage and to define edges, bringing out the white of the flowers.

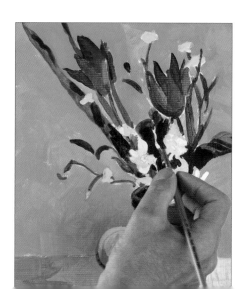

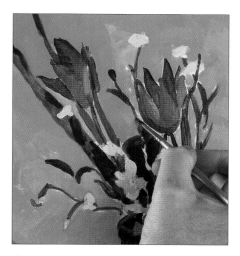

37 Use the same brush and mix to paint stalks and to add dark undersides to some of the tulips.

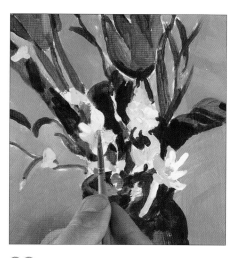

38 Mix cadmium yellow with a little burnt umber and paint centres in some of the white flowers.

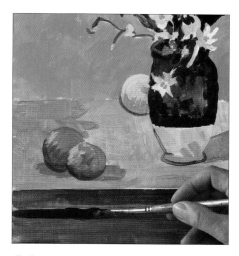

39 Use burnt umber and the medium flat brush to darken the table edge, allowing the background colour to show through.

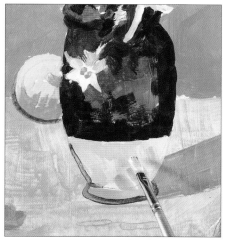

40 Mix a pale, pinkish grey from cerulean blue, alizarin crimson, burnt umber and white, and use the small flat brush to paint diagonal brush strokes over the underpainting on the vase.

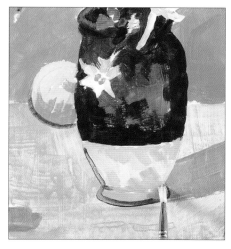

41 Add more cerulean blue to the mix and add more brush strokes on the right, then add more burnt umber and paint around the base.

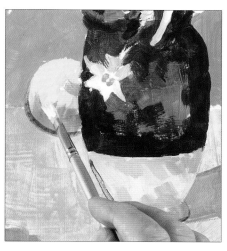

42 Mix cadmium yellow with lots of white and lighten the top edge of the background apple.

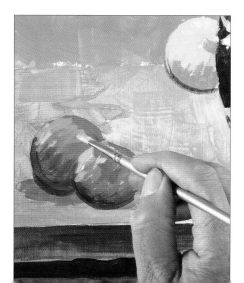

43 Paint the tops of the foreground apples with a mix of cadmium orange, cadmium red and a touch of white.

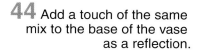

44 Add a touch of the same mix to the base of the vase as a reflection.

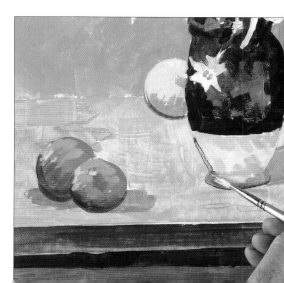

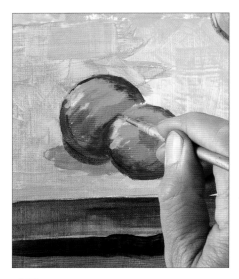

45 Add burnt umber and cadmium red to the mix and use the small round brush to paint the shadowed top right-hand edges of the apples, and the shadow between them.

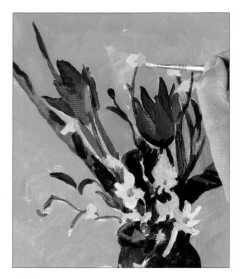

46 Mix cadmium yellow with a little burnt umber to tone down the shadowed areas of the yellow flowers.

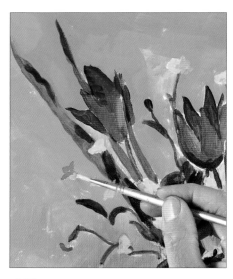

47 Use the same mix to paint a flower on the left. Add more white to paint lighter areas.

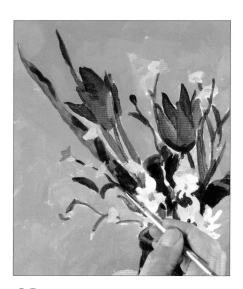

48 Use the lighter mix to add more little flowers, then mix phthalo green and burnt umber and paint the stalk.

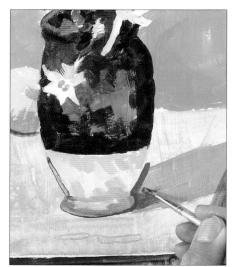

49 Mix phthalo blue, burnt umber and white to paint the edge of the shadow to the right of the vase. Feather out the paint before it dries with diagonal brush strokes.

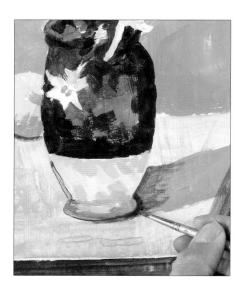

50 Darken the colour further with more phthalo blue and burnt umber, and paint a deeper shadow next to the edge of the vase.

Opposite

The finished painting, reduced in size.

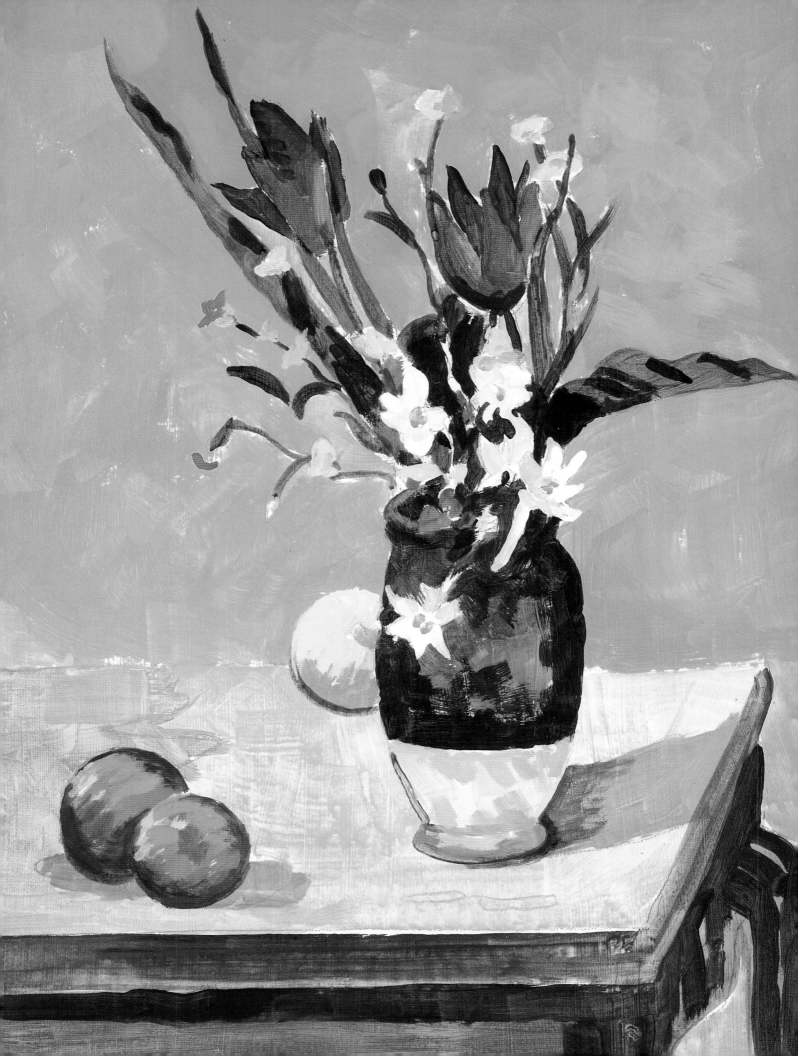

The Card Players

This is one of a series of five paintings of men playing cards that Cézanne did. The image has an almost reverential quality, with a solemn look; it's as if everything else is of little consequence. The focus is on the two men entirely, with the background unclear and out of focus. Carefully posed, the men sit immovable, lost in concentration. The main axis of the painting is almost central and runs through the wine bottle, separating the two figures. On the left, the pipe smoker looks cool and detached, seemingly in control, while on the right, the figure appears more involved, leaning in intently, perhaps anxiously. For me, this theme also seems to have a deeper, allegorical meaning; intellect versus emotion, or conscious against subconscious. I wonder who wins?

You will need

Grey board primed with white gesso

Colours: burnt umber, cobalt blue, titanium white, burnt sienna, cadmium yellow medium, Naples yellow, cadmium orange, alizarin crimson, phthalo green, cadmium red

Hog brushes: large flat, medium flat, small flat, small round

1 Make a dark mix of burnt umber and cobalt blue and dilute it slightly. Use the large flat brush to block in the darkest parts of the painting, then change to the medium flat to paint carefully round the card players' faces.

2 Add more cobalt blue and a little white to grey the mix and paint streaky brush strokes behind the card players, continuing under the table.

3 Add more white and cobalt blue to paint the top right-hand area of the painting, then add still more to paint diagonal strokes in the background, suggesting reflections in the window of the bar.

4 Paint the same grey on the left of the painting, then go over the dark underpainting on the right with loose brush strokes.

5 Add touches of the same grey to the card players' clothes as shown.

6 Add cobalt blue to the mix and paint round the left-hand figure's hat, then break up the space on the left with broad diagonal brush strokes.

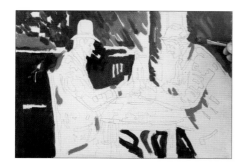

7 Add burnt sienna to warm the original grey made from burnt umber, cobalt blue and white, and paint diagonal brush strokes behind the right-hand man's hat.

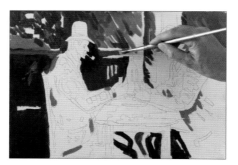

8 Add more burnt sienna and white and paint the back of the bar seat with a horizontal brush stroke. Add touches of the same brown elsewhere.

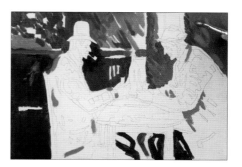

9 Paint carefully around the right-hand figure's face, and add more white and burnt sienna to paint the area in front of him. Add touches of brown to break up the grey behind him.

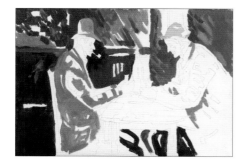

10 Mix burnt sienna, cobalt blue and white to paint the jacket of the man on the left, using loose brush strokes and leaving some white. Add white to paint his hat, and add still more white to block in the hat of the right-hand man.

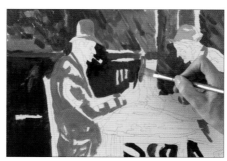

11 Mix a greenish grey from cobalt blue, burnt sienna, white and cadmium yellow medium, and paint diagonal strokes of this across the background. Use the same mix as a base colour for the wine bottle.

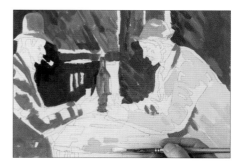

12 Begin to paint the jacket of the figure on the right with a mix of Naples yellow and white. Darken with more Naples yellow to paint the lower part of the jacket. Paint parts of the table with the same mix.

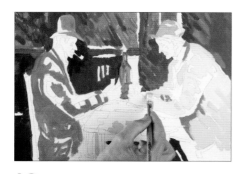

13 Add white and a little burnt sienna to paint the back of the jacket and the further sleeve.

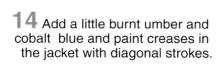

14 Add a little burnt umber and cobalt blue and paint creases in the jacket with diagonal strokes.

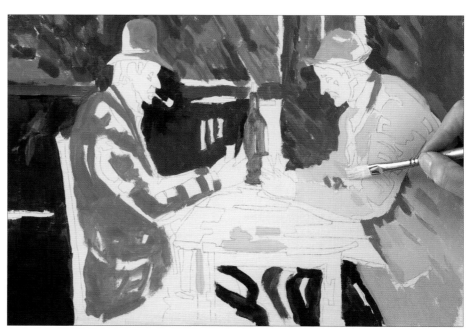

15 Mix burnt umber and cobalt blue to paint the creases in the left-hand man's jacket.

16 Make a darker mix of burnt umber and cobalt blue and use the small flat brush to paint round parts of the men's jackets and around the wine bottle and cards.

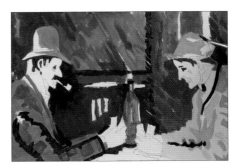

17 Carefully paint the left-hand man's hair and eye with the dark brown mix, then paint the hair and features of the man on the right and shade the back of his hat.

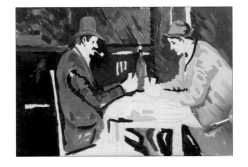

18 Add white and a little cobalt blue to the dark brown mix to make grey. Paint the hair of both figures and add shade to their hats. Use the same colour under the table and at the bottom of the right-hand man's jacket with the medium flat brush.

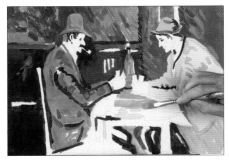

19 Mix burnt sienna with a little Naples yellow and burnt umber and block in parts of the table top with horizontal brush strokes.

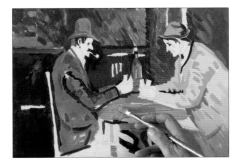

20 Paint the edge of the table and the legs with cadmium orange and burnt sienna, then bring this colour on to the top as well.

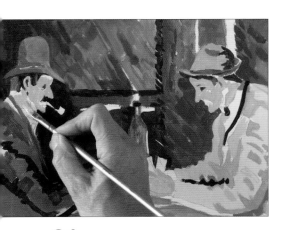

21 Add white to the mix to make a flesh tone and use the small flat brush to block in the faces, necks and hands.

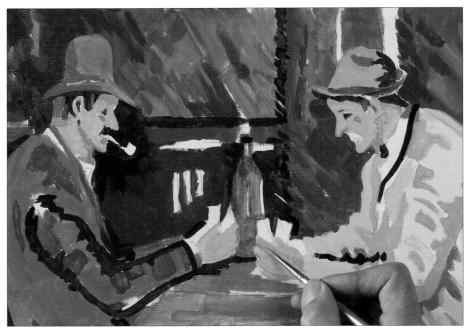

22 Darken the mix with more cadmium orange and burnt sienna and paint the shaded areas, such as the jawlines to shape the faces. Add detail to the hands.

24

23 Use the small round brush and a mix of burnt umber and cadmium orange to paint the moustache on the right-hand man and the shade under his sleeve, and the planking and details of the table.

24 Paint the same orange on to the top of the bar seat behind the figures, and in broad strokes throughout the painting as shown.

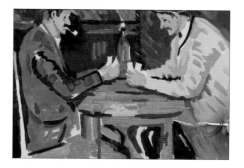

25 Paint the trousers of the left-hand card player with Naples yellow with a little cobalt blue. Add burnt sienna to the mix and paint the overhanging tablecloth with the small flat brush.

26 Use pure titanium white to paint the left-hand man's shirt collar and the playing cards, then add a little burnt umber to shade the cards on the right.

27 Mix burnt sienna, cobalt blue, white and alizarin crimson to make a pinkish grey and use this to paint rectangles of colour on the left-hand man's jacket. Add a little more cobalt blue in places.

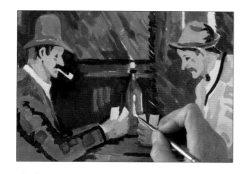

28 Use the small round brush and titanium white to re-establish the stem of the pipe and to paint white highlights on the wine bottle.

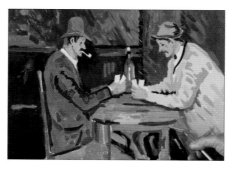

29 Make a grey from burnt umber, white and cobalt blue and paint the chair back. Paint touches of this colour throughout the painting with the small flat brush.

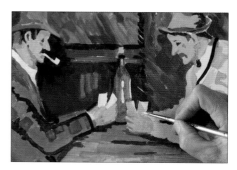

30 Paint the cork with Naples yellow and white, and add shade to the right-hand man's cards with cobalt blue, burnt umber and white on the small round brush.

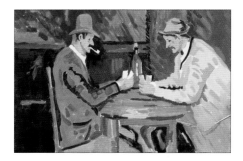

31 Paint diagonal brush strokes on the right-hand man's jacket with cobalt blue, burnt umber and white.

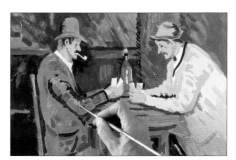

32 Shade the back of the left-hand man's hat with burnt umber and cobalt blue, then mix Naples yellow with a little cobalt blue and paint diagonal strokes on his jacket.

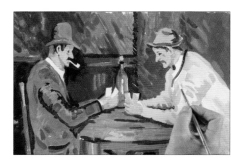

33 Add a little white to the mix and paint tiny diagonal brush strokes on the right-hand man's jacket to soften the edges of the creases. Allow the underpainting to show through.

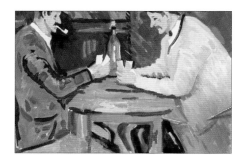

34 Add more cobalt blue to the mix to shade under the arm with the same diagonal brush strokes, then add more burnt umber and continue lower down.

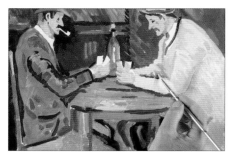

35 Add more burnt umber to redefine the pocket, then more cobalt blue to continue adding shadow round the front and sleeve of the jacket and the shirt.

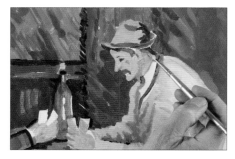

36 Paint more grey around the collar, leaving just a tiny black line, and go over the hair with the grey.

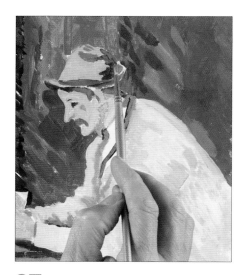

37 Add more burnt umber to the mix and paint texture on the back of the hat with diagonal strokes.

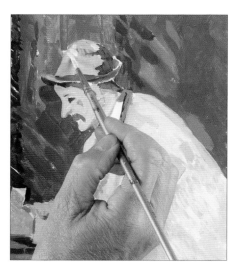

38 Mix burnt sienna and white with a little Naples yellow and paint light touches on the hat.

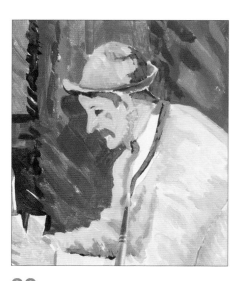

39 Paint pure Naples yellow on the shirt front – this may be a tie in the original painting.

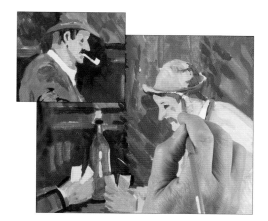

40 Paint both the men's shirts with white and a touch of Naples yellow, then mix burnt sienna and cobalt blue to work over the right-hand man's hair and the shadow under his hat.

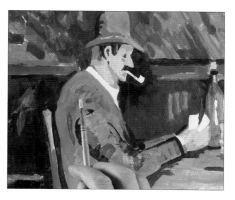

41 Mix cobalt blue, burnt sienna and titanium white and paint diagonal brush strokes on the left-hand man's jacket, allowing the underpainting to show through.

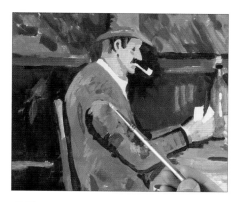

42 Add more Naples yellow and white and paint lighter strokes on the shoulder and back and on the top of the jacket sleeve.

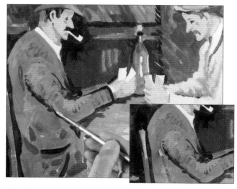

43 Add more cobalt blue and paint diagonal strokes on the underside of the sleeve, then add burnt sienna and paint the shoulder above the sleeve.

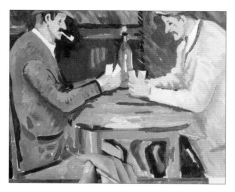

44 Darken the mix with a little cobalt blue and paint the shadow under the sleeve, fading the edges into the underpainting. Paint over the curve below the pocket to lighten it.

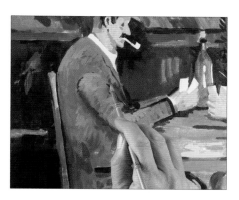

45 Make a darker grey with more cobalt blue and burnt umber and paint down the back and then the front of the jacket in diagonal strokes.

46 Mix a pinkish grey from cobalt blue, burnt umber, white, Naples yellow and alizarin crimson and stroke down with visible brush strokes around the pocket.

47 Paint the top of the hat with burnt sienna and white, then add cobalt blue and paint the shaded side.

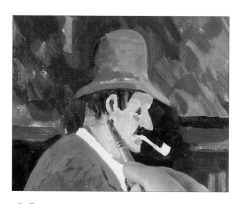

48 Make a dark mix of burnt sienna and cobalt blue and paint the shadow under the hat and the detail of the left-hand man's hair.

49 Paint the same dark mix across the background, slightly diluted, with horizontal and diagonal strokes, scrubbing the colour over the underpainting.

50 Tidy the legs of the right-hand figure, then mix white, Naples yellow and burnt sienna and paint the left-hand man's trousers.

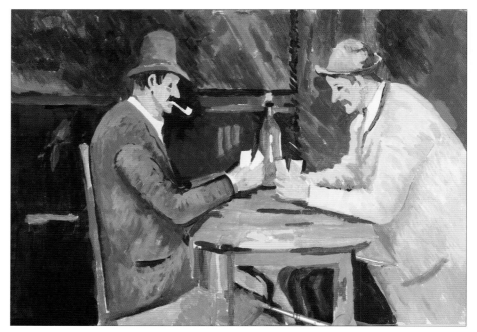

51 Mix a pale blue-grey from cobalt blue, burnt umber and white and re-establish the floor between the card players, making it darker at the top.

52 Mix Naples yellow and white with burnt umber and paint touches on the left-hand man's trousers and sleeve.

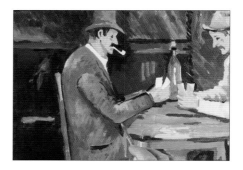

53 Make a dark grey from burnt umber, cobalt blue and white and paint the cuff and under the sleeve of the left-hand man.

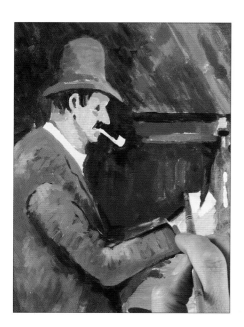

54 Darken the brown a little and paint over the background around the left-hand figure to redefine him. Paint over some of the brighter orange marks to subdue them.

55 Redefine the right-hand figure's features in the same way, by darkening the background.

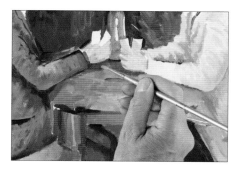

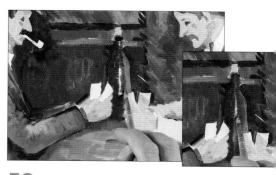

56 Mix cadmium orange, cadmium red, burnt sienna and white and paint horizontal brush strokes on the table, allowing the underpainting to show through.

57 Add cobalt blue to the mix and paint shadow under the hands and wine bottle.

58 Subdue the bottle colour with a mix of cobalt blue, burnt umber, alizarin crimson and phthalo green. Add a reflection on the right with burnt sienna, burnt umber and white, and paint a white streak for the highlight.

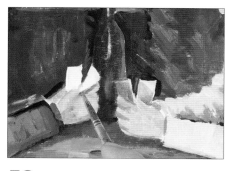

59 Shade the playing cards further with a mix of burnt umber, cobalt blue and white.

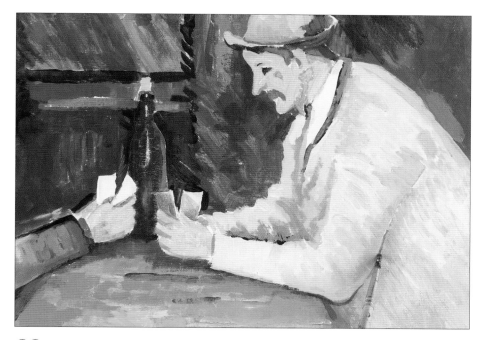

60 Add shadow to the undersides of the arms with cobalt blue, burnt umber and a little white.

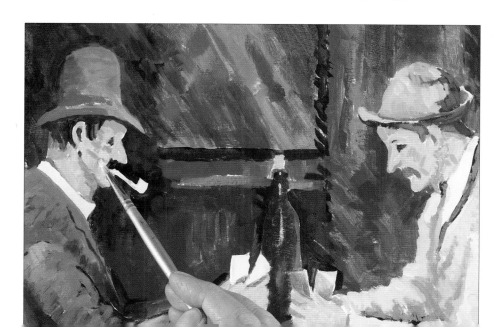

61 Mix white with a little cadmium orange and cadmium red and stroke this on to the men's faces.

62 Shade the right-hand man's chin and ear with the same mix with burnt umber added.

63 Shade the left-hand card player's features in the same way.

64 Mix white with a little burnt sienna and cadmium orange and add light touches to the man's face.

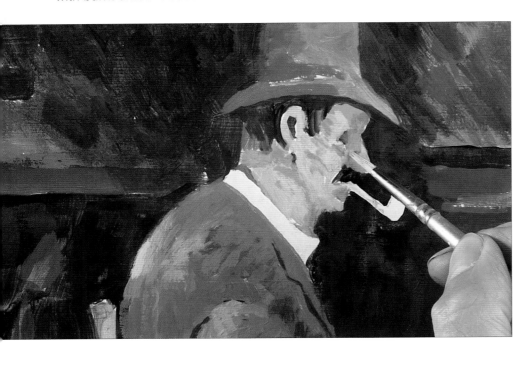

65 Use dilute burnt umber to add shade on the left-hand man's face and to subdue the eyes of both figures.

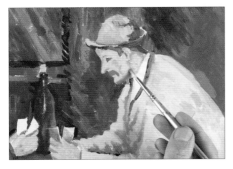

66 Mix burnt umber and white and paint the moustache of the right-hand man, then add shade under his chin.

67 Make a mix of burnt umber, cobalt blue and white and paint shade down the right-hand man's jacket.

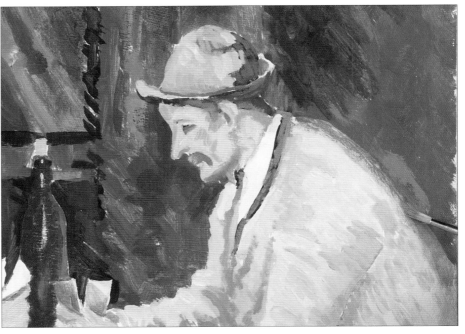

30

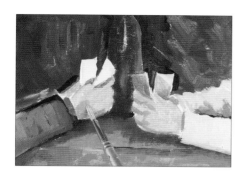

68 Mix titanium white, cadmium orange and burnt sienna and paint hints of this on the men's hands.

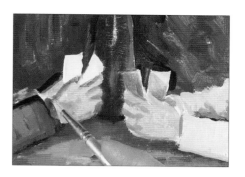

69 Add burnt umber to the mix to refine the fingers and then add form to the hands.

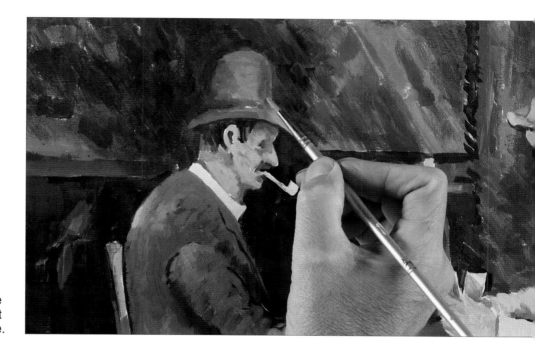

70 Shade the front of the left-hand man's hat with burnt umber and white.

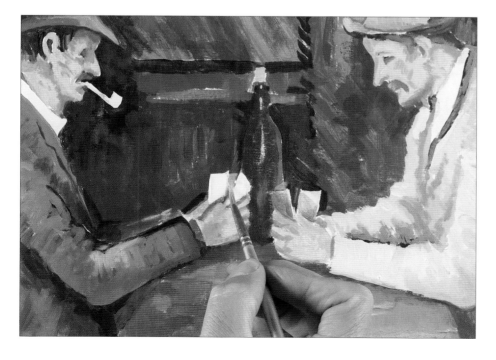

71 Subdue the brightness of the playing cards with titanium white, cobalt blue and a little burnt umber.

Overleaf

The finished painting.

31

Mountains in Provence

In the original painting it appears that every brush stoke has been deliberated over then applied in precisely the right place. Cézanne would often sit for many minutes, gazing intently at the scene, before taking a brush and making just one solitary mark on the canvas. This image seems to hint at the beginning of what was to become known as 'abstract' art; there are areas on the painting where it is not obvious what things are or where they sit in relation to the rest, but this adds to the impact. The buildings are hinted at rather than applied exactly, and the colour of them echoes the colour of the soil. The strong blue of the lake is also to be found in the background mountain. This painting is, for me, extremely evocative of the hot, almost arid South of France in summer.

TRACING

4

You will need

Grey board primed with white gesso

Colours: titanium white, Naples yellow, cadmium orange, burnt sienna, burnt umber, cobalt blue, alizarin crimson, phthalo green, lemon yellow, cadmium red

Hog brushes: medium flat, small flat, small round

1 Mix titanium white and Naples yellow, dilute it slightly and use the medium flat brush to block in the straw-coloured parts of the painting. Don't worry if you go over the lines as they should still show through.

2 Add more Naples yellow lower down, then add more white to paint the distant lighter parts of the mountains.

3 Add cadmium orange and burnt sienna to the mix and paint on top of the first mix with horizontal and diagonal brush strokes, following the shape of the land. Add burnt umber for a browner mix in places.

4 Mix titanium white, cobalt blue, burnt umber and a little alizarin crimson and paint the sky with short brush strokes. While it is wet, apply a darker mix on top. Leave the paint only partially mixed, to create a streaky effect. Add more burnt umber and blue on the right.

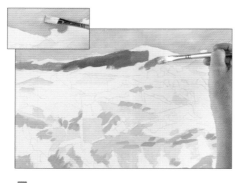

5 Add more cobalt blue, burnt umber and alizarin crimson and paint the mountain. Mix in more white to create streaks.

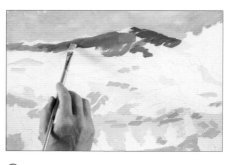

6 Add cobalt blue and paint the right-hand side of the mountain, then paint diagonal strokes of the same blue on the left.

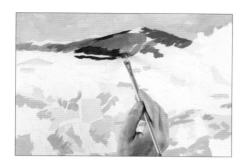

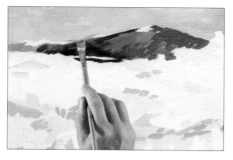

7 Mix burnt umber and cobalt blue to make a very dark grey and paint the darker areas of the mountains.

8 Add a bit of white to the mix and paint this on with diagonal brush strokes. Paint the edges of some of the distant mountains with the same pale grey.

9 Block in the grey area beneath the mountains, which may be a quarry that has been reduced to an abstract shape. Add Naples yellow to the mix and paint with streaky brush strokes over the grey.

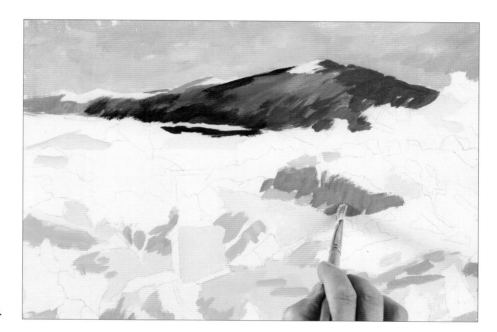

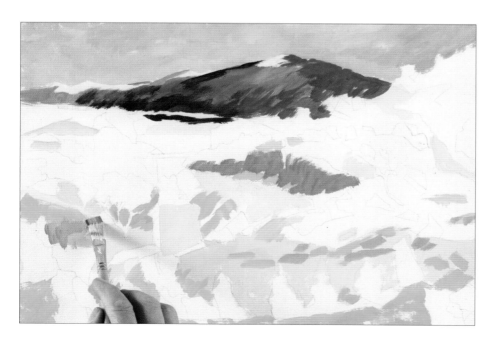

10 Fill in more of the grey areas around the painting, using strong vertical lines.

11 Paint some of the very pale grey in the foreground.

12 Paint the pale grey part of the building with the same mix.

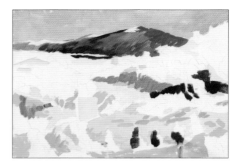

13 Make a dark green mix of cobalt blue, burnt umber and phthalo green and paint this on some of the darkest parts of the painting with strong, vertical brush strokes, including the shaded sides of the trees in the foreground.

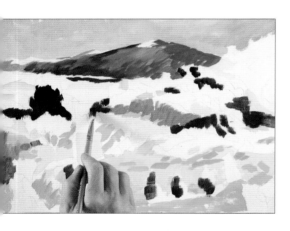

14 Continue painting the dark green on the dark areas of foliage throughout the painting.

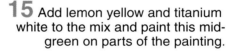

15 Add lemon yellow and titanium white to the mix and paint this mid-green on parts of the painting.

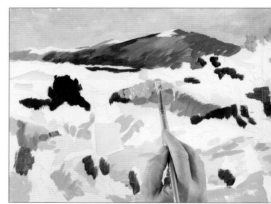

16 Paint the mid-green on the foreground trees with strong, vertical strokes. This will be worked over later with smaller brushes.

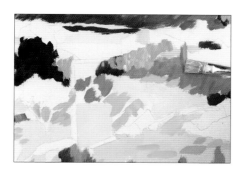

17 Continue adding touches of the mid-green. Dip the brush in the green and then in yellow and white to create a streaky effect, and paint this on with the flat edge of the brush.

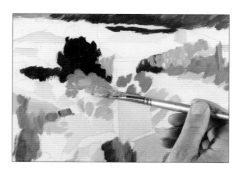

18 There is a prominent tree on the left that is painted entirely with horizontal brush strokes, so paint in some of these strokes with the streaky green.

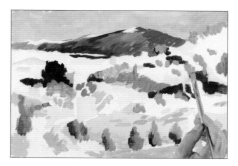

19 Paint more blocks of green on the right-hand hill. These may be trees that have been abstracted in the painting.

20 Mix lemon yellow, phthalo green, titanium white and a little cadmium orange and use the small flat brush to add little touches of this in the foliage.

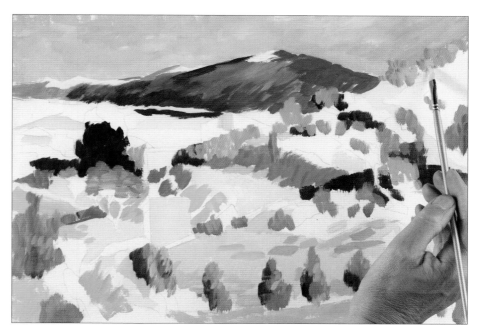

21 Continue painting areas of the warmer green. Add white to paint the more distant trees with paler touches.

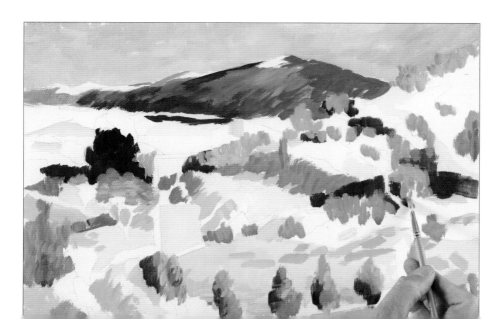

22 Add phthalo green and white to the mix to make it brighter and cooler, and intersperse this green among the others with small diagonal and vertical brush strokes.

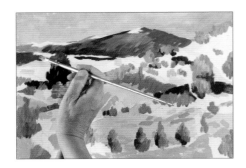

23 Continue painting with the cooler green, then add more of the warm green mixed from lemon yellow, phthalo green, titanium white and a little cadmium orange. Mix phthalo green, burnt umber and white and paint in darker tones on the left-hand side.

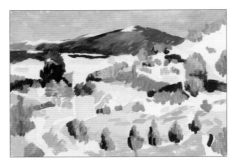

24 Add more burnt umber to make a very dark green and paint the left-hand sides of the foreground trees.

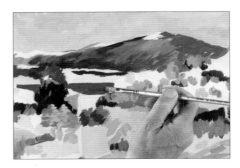

25 Mix cobalt blue and alizarin crimson to paint the lake. Add more alizarin crimson to create purple streaks.

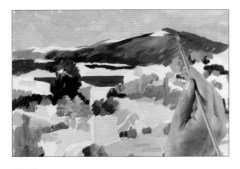

26 Paint some of the same colour on to the right-hand side of the main mountain.

27 Mix Naples yellow, white and cadmium orange to paint the shapes to the left of the lake, which may be buildings.

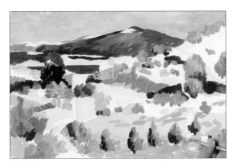

28 Add burnt sienna to the mix and add touches to the landscape with streaky, diagonal brush strokes, varying the mix.

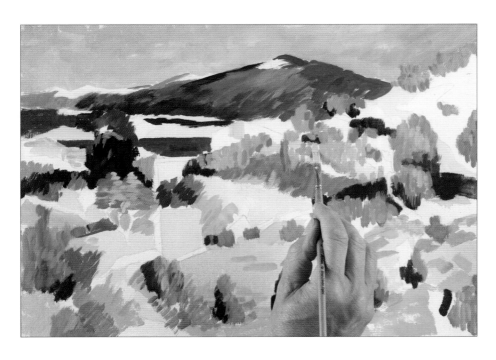

29 Continue painting diagonal strokes of the brownish mix, then add white and a touch of cobalt blue to grey it. Paint with this paler colour in between the green blocks that may be abstracted trees, and in the grey area that may be a quarry.

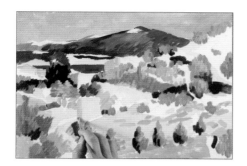

30 Paint the same mix on the shaded side of the abstracted building in the middle ground.

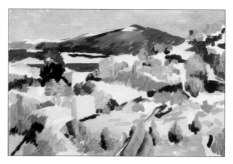

31 Mix cobalt blue, burnt umber and a touch of white to make a very dark grey and begin to paint the darkest areas of the painting with loose, diagonal brush strokes.

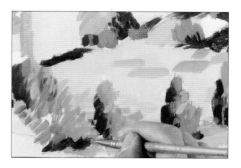

32 Paint the dark shadowed area under the trees.

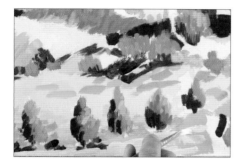

33 Make a light mix of Naples yellow, white and a little burnt sienna and paint the area below the foreground trees.

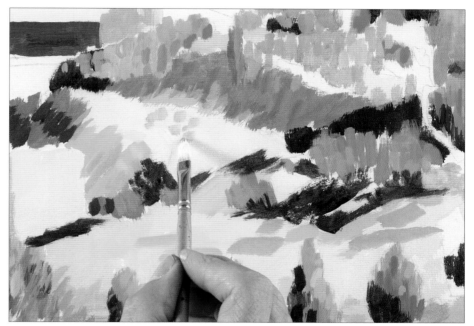

34 Paint touches of the same mix to break up flat areas of colour in the painting. Use a dry brush to hint at the foliage of a tree in a field in the centre of the scene.

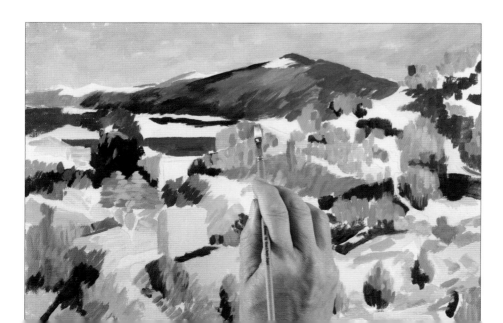

35 Mix cobalt blue and burnt umber with a little white and paint this dark grey on buildings and other dark shapes.

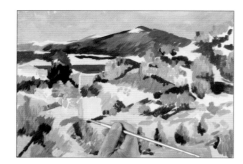

36 Add a little more white and continue painting grey buildings and shadows throughout the scene.

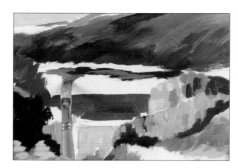

37 Paint lighter grey streaks on the dark line behind the lake.

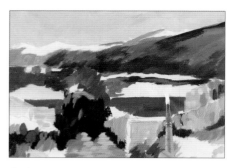

38 Use the small round brush with white and a touch of Naples yellow to paint the light area behind the lake with little vertical brush strokes.

39 Continue painting little vertical strokes of the very light colour on light areas such as the building in the middle ground and the central field.

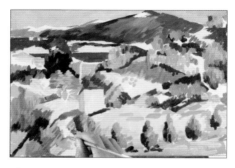

40 Add burnt sienna and burnt umber to the mix and paint diagonal strokes of this browner colour, adding texture. Vary the brown and use it to break up flat areas of colour.

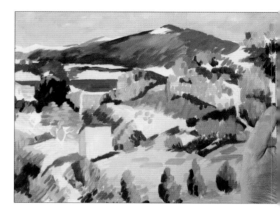

41 Mix burnt umber, cobalt blue and alizarin crimson and paint very dark diagonal strokes on top of previous dark areas.

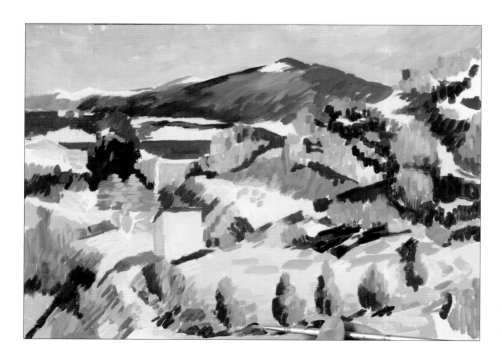

42 Paint the darks under the foreground trees and new dark details on the right of the painting with the same mix.

40

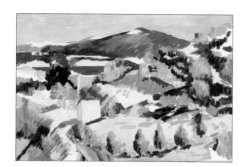

43 Mix a red-brown from burnt sienna, cadmium red and white and paint touches of this on the browner areas of the painting.

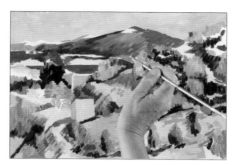

44 Add cadmium orange to the mix and continue painting touches around the painting. Paint the bright orange roof.

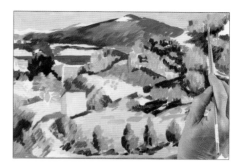

45 Vary the brown by adding cobalt blue, burnt umber and white and paint some more strokes on the right of the painting.

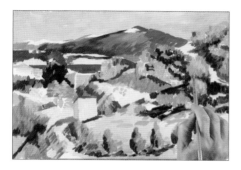

46 Mix phthalo green, lemon yellow and white and add hints of this vivid green among the foliage.

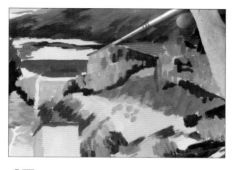

47 Make a bright orange-red with cadmium red and lemon yellow and paint the edge of the red roof.

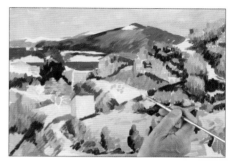

48 Mix Naples yellow, lemon yellow and white and paint diagonal brush stokes on some of the straw-coloured areas, following the pattern on the land.

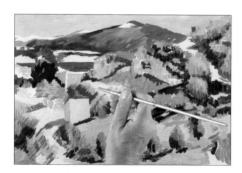

49 Add a little phthalo green to the mix and paint touches of this in the trees.

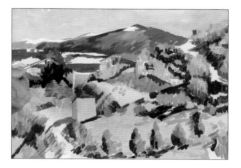

50 Mix burnt umber and phthalo green with Naples yellow and paint some of the darker trees on the left.

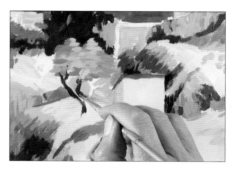

51 Paint dark areas around the middle ground building and in the trees behind it with a mix of cobalt blue and burnt umber, then paint the tree trunk to the left in the same way.

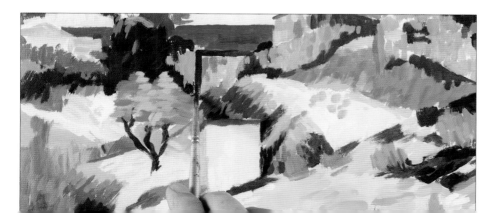

52 Add white to paint darker tones to the grey shape behind this building, then use the darker mix to paint a dark outline.

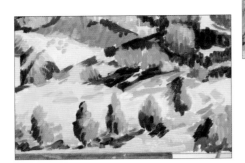
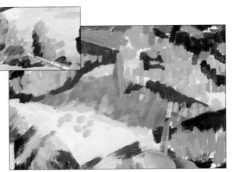
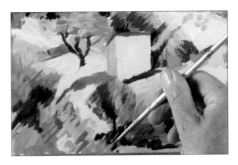

53 Paint darks at the bottom right of the painting, then blend the dark areas into grey.

54 Add more white and paint touches of pale grey around the painting over areas of grey underpainting. Add a tiny touch of burnt umber and paint this browner pale grey over the large grey area.

55 Use a dark mix of burnt umber and cobalt blue to paint the dark shadow under the foreground tree in diagonal brush strokes. Mix phthalo green and Naples yellow to paint the green area in front of this.

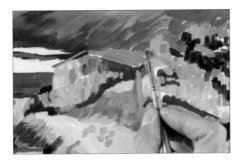

56 Subdue this bright green with a little burnt sienna and paint the mid-greens around the red roof.

57 Mix cobalt blue and burnt umber and paint dark lines around the central field.

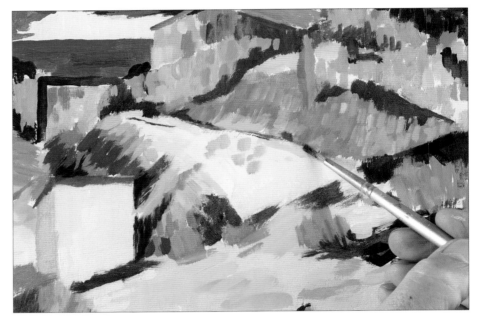

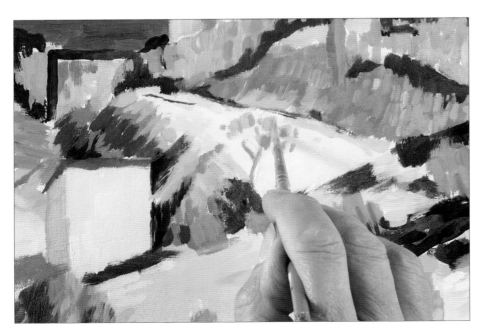

58 Mix burnt sienna and cadmium orange and paint the trunk of the tree in the central field.

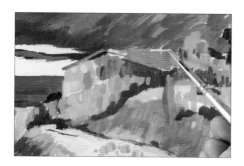

59 Add Naples yellow to the orange and paint highlights on the red roof.

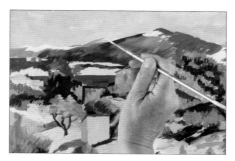

60 Mix a very pale grey from white with cobalt blue and burnt umber and use this to calm down the very light parts on the mountain tops.

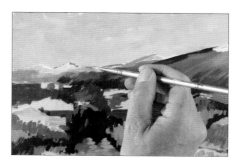

61 Dilute the very dark grey a little and paint a tiny outline for the distant mountains.

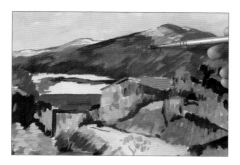

62 Mix a plum colour from alizarin crimson, burnt umber and a touch of cobalt blue and paint this on the mountain.

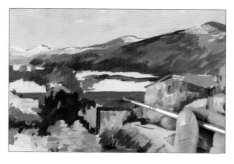

63 Add a reflection of this colour in the lake.

64 Paint diagonal touches of burnt umber and cobalt blue on the mountain, then add white and paint lighter brush strokes.

65 Darken the trunk of the tree in the central field with burnt sienna.

Overleaf

The finished painting.

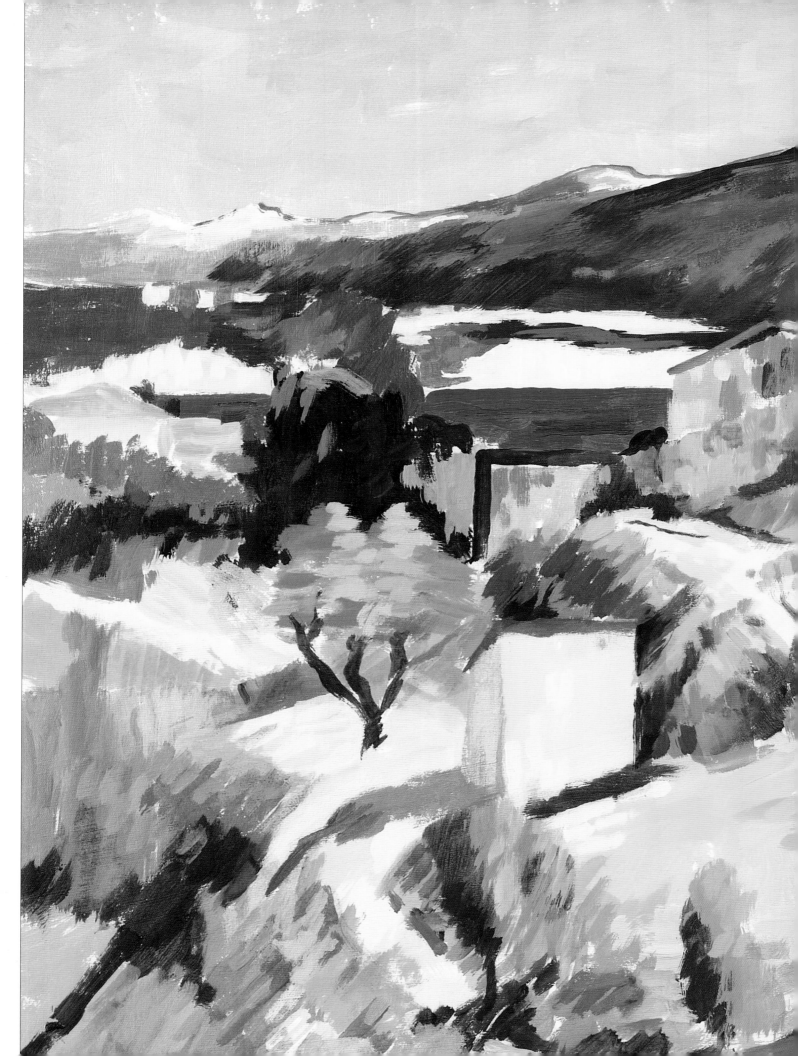

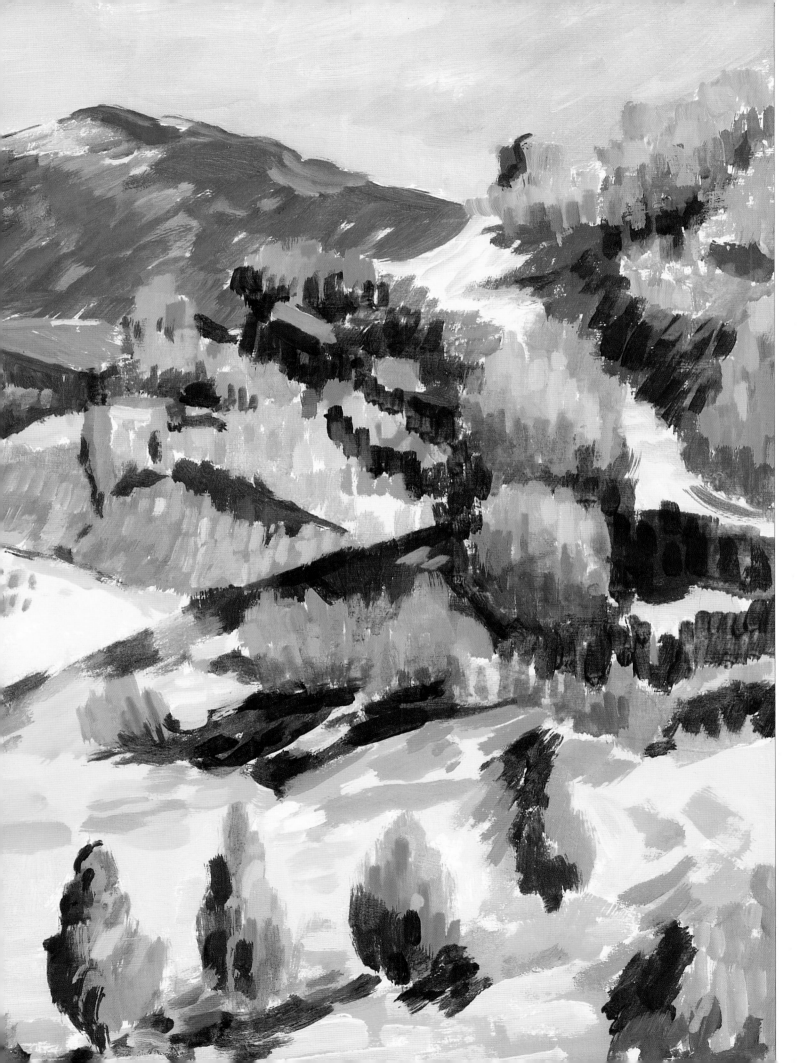

Lakeside Houses

Here, I have taken several of Cézanne's favourite motifs and incorporated them into one image. The strong directional brush strokes are mainly diagonal, apart from the water and some of the buildings. There is quite a lot of pale brown and orange/yellow in the buildings and on the ground; this enhances the feeling of warmth. The clearly defined tree trunks provide some strong verticals. Reflections are put on with simple slabs of colour in a horizontal direction, to give stability to the base of the image. When painting this, try and paint with single strokes of colour, allowing the shape of the flat brush to make distinctive marks.

You will need

Grey board primed with white gesso

Colours: titanium white, cerulean blue, alizarin crimson, burnt umber, Hooker's green, Naples yellow, cadmium yellow medium, cadmium orange, burnt sienna, cobalt blue, cadmium red

Hog brushes: Large flat, small flat, small round, medium flat

1 Block in the sky with a large flat brush and a dilute mix of titanium white, cerulean blue and a little alizarin crimson. Paint round branches but over parts where foliage will be.

2 Add more white and alizarin crimson to make a very pale pinkish grey and paint this on with diagonal brush strokes.

3 Add lots of cerulean and a little burnt umber to make a bluey grey and paint in the distant hill with vague brush strokes.

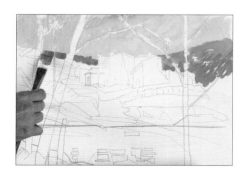

4 Add Hooker's green and burnt umber to the mix and paint the greener part of the distant hills on either side of the houses with short diagonal brush strokes.

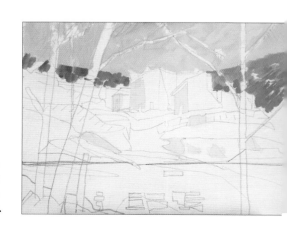

5 Paint the light parts of the houses and the rocky shapes near the water's edge with Naples yellow and white.

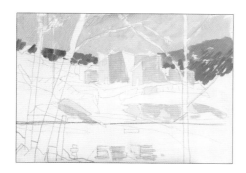

6 Mix cerulean blue with alizarin crimson to paint the shadowed sides of the houses and rocks, and the reflections of the houses in the lake.

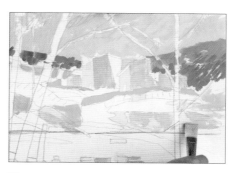

7 Use a mix of Hooker's green, cadmium yellow medium and white to paint a pale green around the rocky area with loose brush strokes.

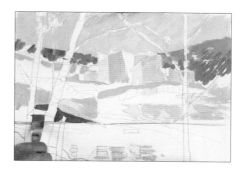

8 Paint darker areas of green with Hooker's green and burnt umber with a little white.

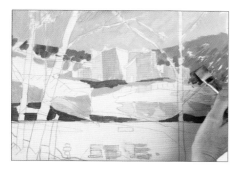

9 Continue to paint darker areas of green. Work up into the hills on the right-hand side, using diagonal brush strokes.

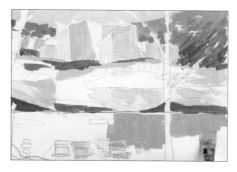

10 Mix a grey-blue from cerulean blue, Hooker's green, white and a little burnt umber and paint the water with broad, downward strokes. Let some white show through and paint round the reflections.

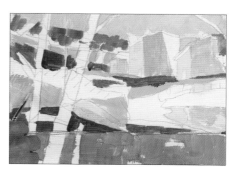

11 Change to the small flat brush and a mix of Hooker's green, cadmium orange and Naples yellow, and paint touches of this very warm green on top of the light green with diagonal strokes.

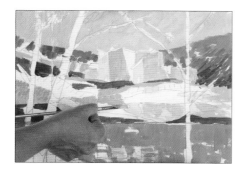

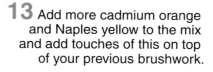

12 Continue painting in this way, then block in the area leading down to the water.

13 Add more cadmium orange and Naples yellow to the mix and add touches of this on top of your previous brushwork.

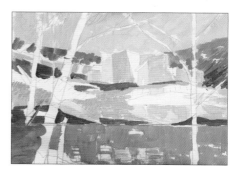

14 Make a dark green from Hooker's green and a bit of burnt sienna and paint this in short, vertical brush strokes at the foot of the hills.

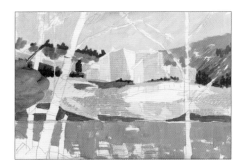

15 Add cerulean blue to the mix to paint the trees in the distance.

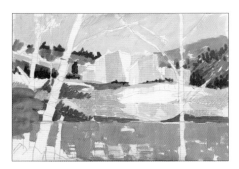

16 Make the mix greyer by adding more burnt sienna and white, and use this to paint diagonal brush strokes on the shadowed side of the lakeside rocks.

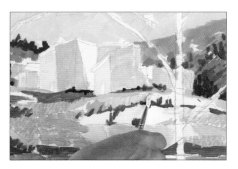

17 Paint the rocks beneath the house in the same way, then add titanium white and Naples yellow to make a pale, warm grey, and paint diagonal strokes on the rocks.

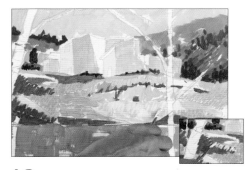

18 Add a little more white and paint the rocks down to the shoreline with diagonal strokes. Use the small round brush to paint little lines of highlight on some areas of rock.

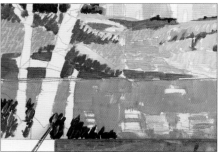

19 Still using the small round brush, paint grasses in the foreground with a mix of Hooker's green and burnt sienna. Add cadmium orange to the mix and paint strokes of this colour on top.

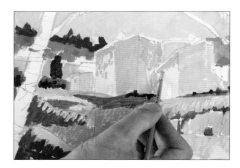

20 Paint small vertical strokes of cadmium orange and Naples yellow on the houses.

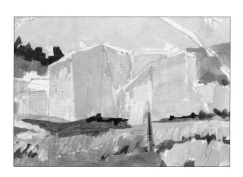

21 Add white to make a very light version of the colour and paint the sunlit parts of the buildings.

22 Use the same colours to paint the reflections.

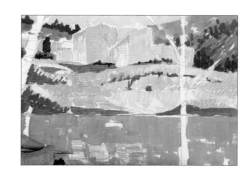

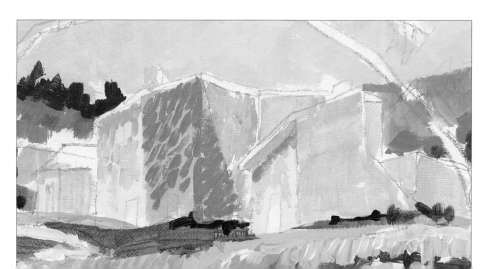

23 Mix cobalt blue, Naples yellow, white and alizarin crimson to make a purple-grey and paint shadows on the buildings with diagonal strokes.

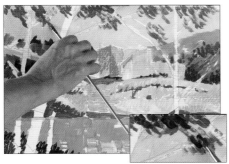

24 Paint the masses of leaves at the top of the painting with the small flat brush and a mix of Hooker's green, burnt sienna and cobalt blue, keeping your curved, diagonal brush strokes sketchy and loose and leaving the sky blue showing. Add more Hooker's green and burnt sienna and paint some darker foliage on top.

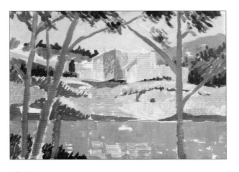

25 Use the medium flat brush and a mix of burnt umber, cerulean blue, alizarin crimson and a touch of white to block in the tree trunks. Use the edge of the brush for the branches and leave gaps for foliage.

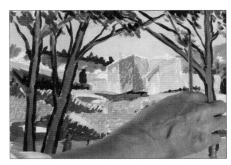

26 Change to the small round brush and use a diluted mix of burnt umber and cerulean blue to outline the trees and to add some branches.

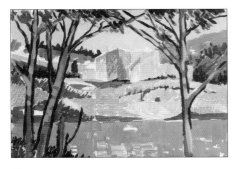

27 Use the medium flat brush and a mix of white, alizarin crimson and cadmium orange to paint rectangular shapes on the tree trunks, suggesting variations in the bark.

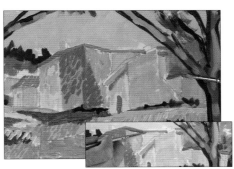

28 Paint the terracotta of the roof with cadmium red, cadmium orange and white on the small flat brush, then paint the door with pure cadmium red. Add alizarin crimson to the mix to paint the more shadowed roofs, then add burnt umber to paint shadow under the eaves.

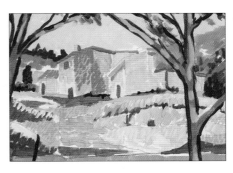

29 Paint the remaining windows and doors with the same darker mix.

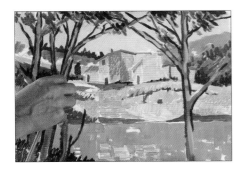

30 Use the medium flat brush with a mix of cerulean blue and white with a little burnt umber to paint down the sides of the tree trunks here and there.

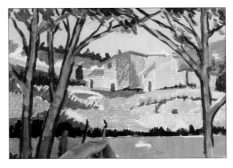

31 Mix Hooker's green with burnt umber and use the small flat brush to paint grass at the water's edge with strong vertical lines.

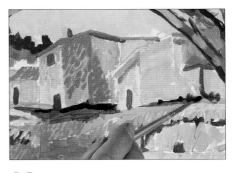

32 Paint dark shadows under the buildings with the same mix.

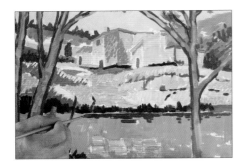

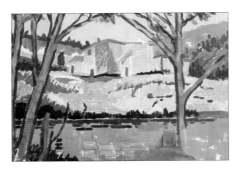

33 Add a little white to the dark green mix and paint horizontal brush strokes at the water's edge for reflections of the dark grasses.

34 Add more white and use the large flat brush to paint broad vertical strokes for reflections.

35 Mix cerulean with a little Hooker's green and use the small flat brush to paint the line of distant trees which help to define the edges of the buildings.

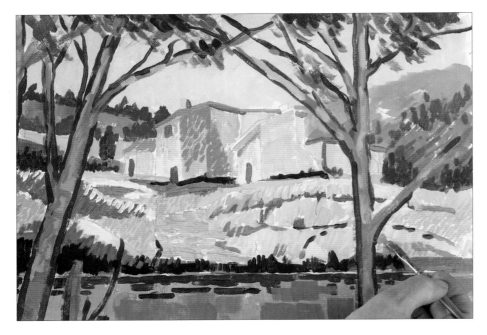

36 Add white to the mix and paint blue-grey touches on top of the dark green areas, then paint shadows under the rocks.

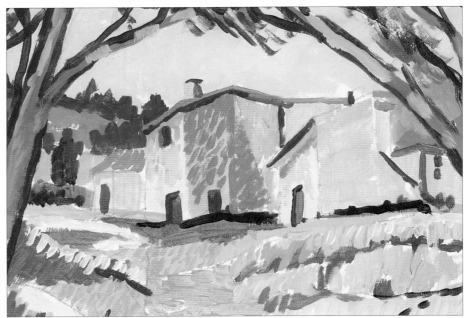

37 Mix burnt umber and cerulean and use the small round brush to paint details on the buildings.

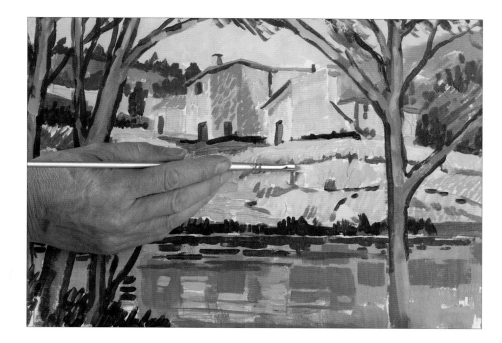

38 Use the small flat brush with a mix of white, cadmium red and cadmium orange to paint little horizontal streaks for reflections. Also paint vertical and horizontal brush strokes on top of the rocks to warm them.

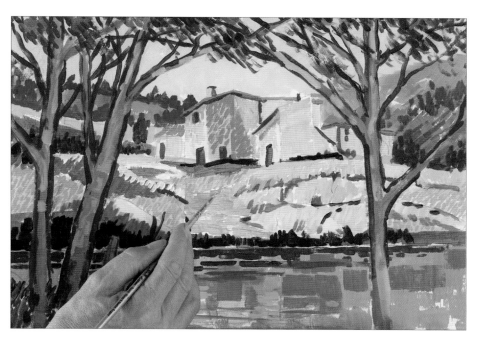

39 Add more cadmium orange and paint little orange touches among the greens in the picture.

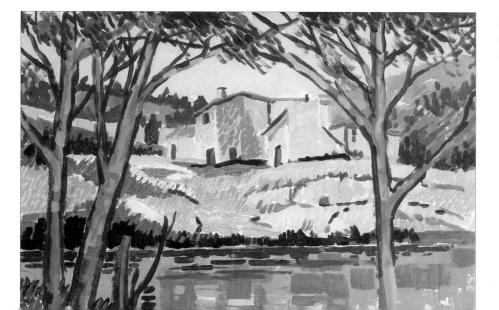

40 Continue adding diagonal touches of the same colour to warm up the painting overall.

Overleaf

The finished painting.

51

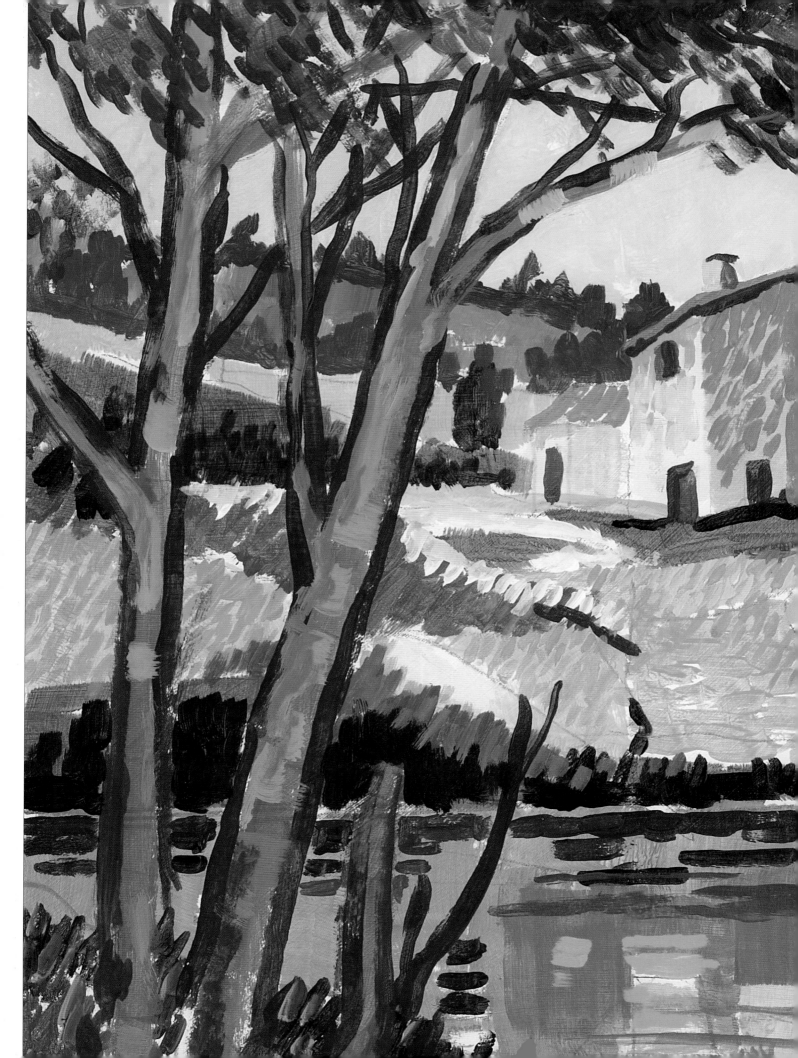

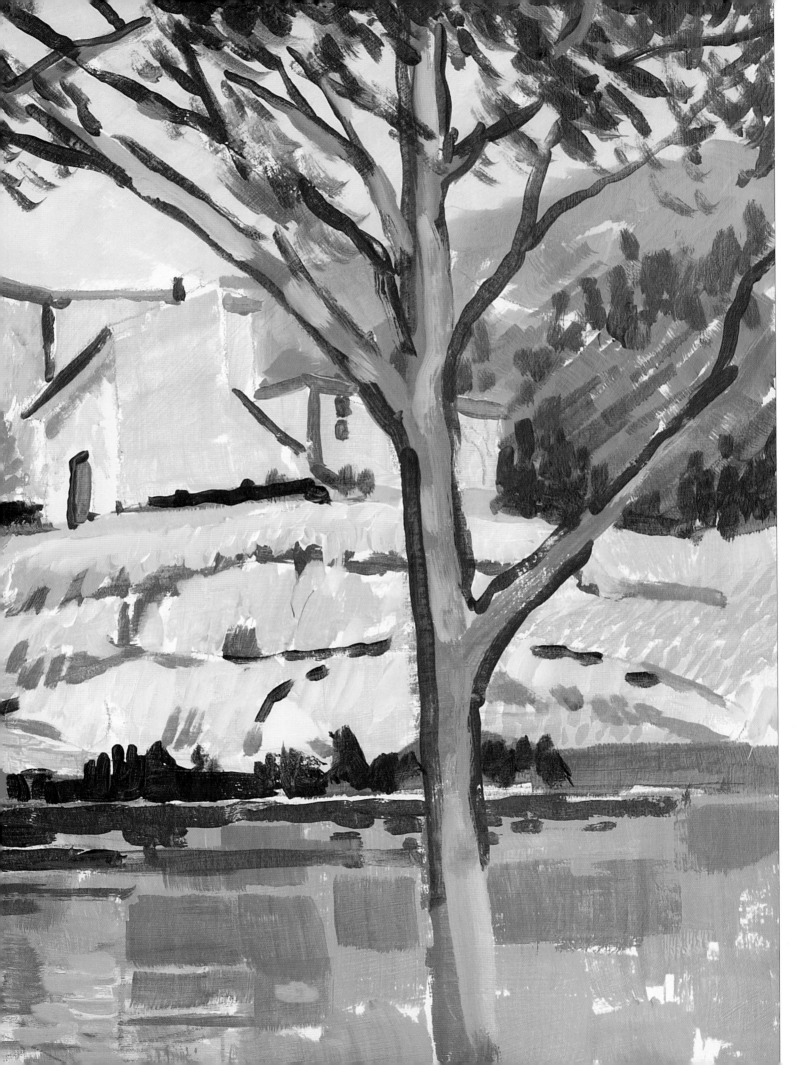

Still Life Jug and Fruit

Cézanne made the still life subject his own, and excelled at painting them; through the continual study of form, he was able to achieve mastery over his technique. It was the precise arrangement of fruit, pots, jugs or jars, and the shadows produced on cloth or furniture, that enabled him to render his sensations of the natural forms. In this painting I have taken one of my jugs and arranged fruit in a shallow bowl, as Cézanne may have done. The background is deliberately irregular and fuzzy, and, as long as you keep the colours similar in tone (darkness or lightness) to mine, you do not have to be too careful with it. The detail is around the lip of the jug, and some of the edges of the fruit, where the dark lines introduce impact and separate each item from its neighbour. As you paint this, be aware of the direction of the brush strokes; it is this that will make your image look strong and lively.

TRACING

6

You will need

Grey board primed with white gesso

Colours: Hooker's green, cobalt blue, burnt umber, titanium white, Naples yellow, alizarin crimson, cadmium orange, cadmium red, burnt sienna, lemon yellow

Hog brushes: large flat, medium flat, small flat, small round

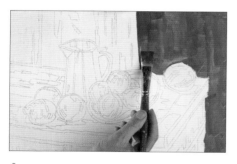

1 Mix Hooker's green, cobalt blue, burnt umber and white and use the large flat brush to block in the darks on the right-hand side.

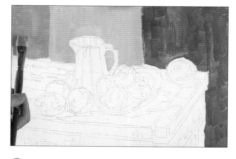

2 Add Naples yellow and white and paint the background curtains, varying the mix and painting round the jug. Add more white to the original green mix to paint the left-hand side.

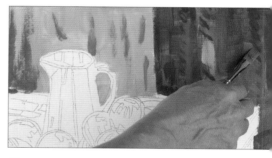

3 Mix cobalt blue, alizarin crimson, white and Naples yellow and use the medium flat brush to paint diagonal brush strokes down the curtain, giving the impression of folds and perhaps a pattern.

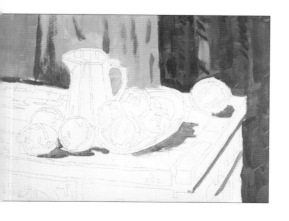

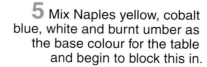

4 Use the same colour to paint the shadowed areas of the painting under the fruit, plate and table edges.

5 Mix Naples yellow, cobalt blue, white and burnt umber as the base colour for the table and begin to block this in.

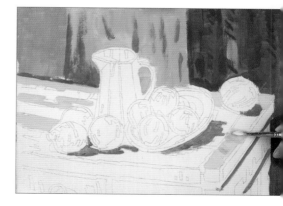

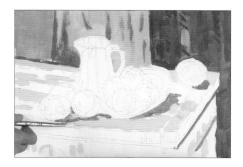

6 Mix Naples yellow and white with cadmium orange and paint this under the fruit and plate.

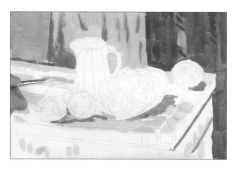

7 Add more cadmium orange to the mix and brush this in with loose brush strokes.

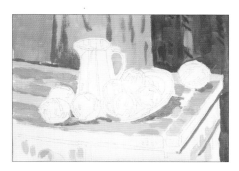

8 Add burnt umber and cobalt blue to the orange mix and continue painting the woodwork of the table, following the shape of the planking.

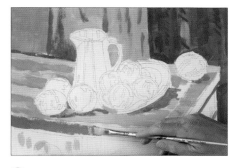

9 Add a little more burnt umber to darken the mix and paint the edge of the table.

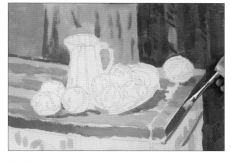

10 Paint the shaded edge using a darker mix with more burnt umber and cobalt blue.

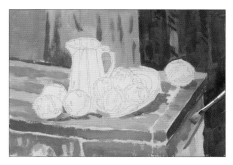

11 Add white and cadmium orange to paint the drawers at the front, then a tiny bit of alizarin crimson and cobalt blue to paint the shaded right-hand side.

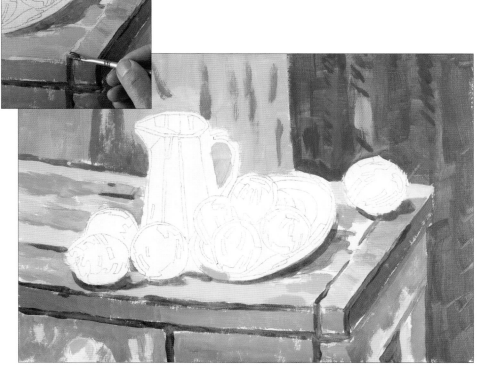

12 Use the small flat brush and a slightly diluted mix of cobalt blue and alizarin crimson to paint the gaps between the drawers and the body of the table, and other dark, shadowed areas as shown.

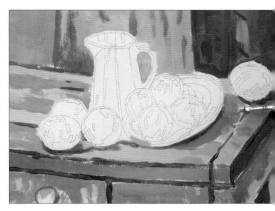

13 Paint a line round the drawer handle with the same mix, then add a little white to paint the shadows under the plate and fruit.

14 Mix cadmium red and burnt sienna and use the medium flat brush to paint the apple on the far right.

15 Add alizarin crimson to the mix and paint the lower part of the apple.

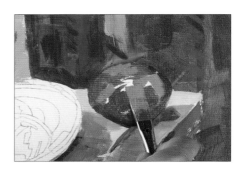

16 Add cadmium orange and white and paint the lighter parts of the apple.

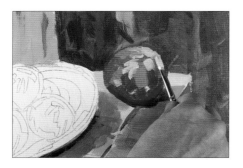

17 Change to the small flat brush and use a mix of cadmium orange, white and lemon yellow to paint highlights.

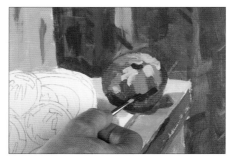

18 Mix alizarin crimson and burnt sienna and paint the darkest shadowed areas of the apple.

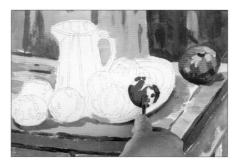

19 Use the same mix to paint the shadowed area of the right-hand apple in the plate. Change to a mix of cadmium red and alizarin crimson and paint the mid-tones with small vertical brush strokes.

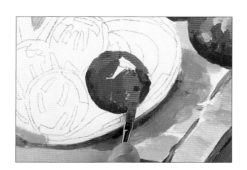

20 Add cadmium orange to the mix and paint the slightly lighter tones of the apple in the same way.

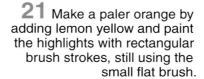

21 Make a paler orange by adding lemon yellow and paint the highlights with rectangular brush strokes, still using the small flat brush.

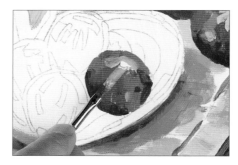

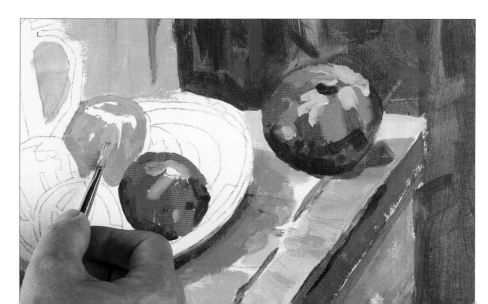

22 Paint the apple behind this one with a mix of cadmium orange, lemon yellow and a touch of burnt sienna. You should still be able to see the lines of the tracing through the paint. Add white to paint the lighter parts.

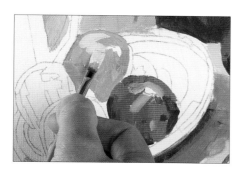

23 Add more white and lemon yellow to the mix to paint the highlights on this apple.

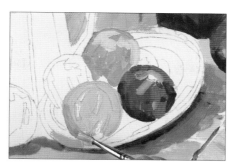

24 Paint the apple in the front of the plate with lemon yellow with a touch of burnt sienna and white. Add a little more burnt sienna and paint the shaded parts.

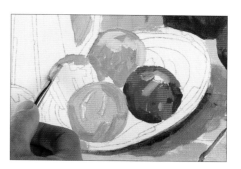

25 Paint the shaded parts of the apple behind this with the same mix.

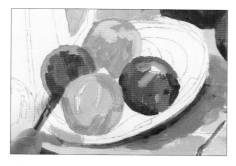

26 Add more burnt sienna and some alizarin crimson and paint the darker parts of the apple behind.

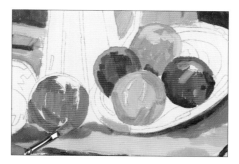

27 Paint the apple in front of the jug with the same mix and single vertical brush strokes, then add lemon yellow and a little cadmium orange to paint the lighter parts.

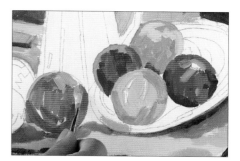

28 Clean the small flat brush thoroughly, then pick up a mix of lemon yellow with a tiny bit of Hooker's green and white, and paint on strokes of this bright green.

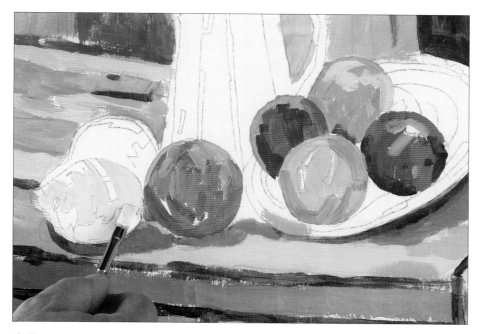

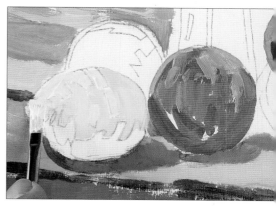

30 Paint lighter touches around the top of the lemon with lemon yellow and white.

29 Add more lemon yellow to paint the highlights among the bright green. Paint the lemon on the left with lemon yellow with a little cadmium orange and white.

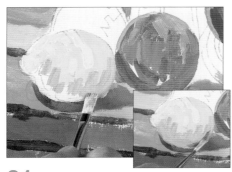

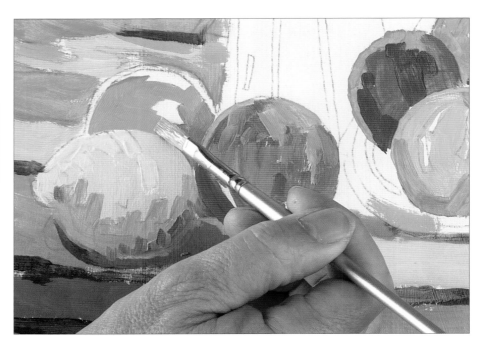

31 Add burnt sienna to the mix and paint the shaded areas of the lemon with vertical strokes. Darken the mix still further with burnt sienna for the darkest shade at the bottom.

32 Paint the green apple behind the lemon with Hooker's green, lemon yellow and white.

33 Change to the small round brush, add more white to the mix and paint the highlights.

34 Mix alizarin crimson and burnt sienna and paint a dark line at the bottom of the apple at the front of the plate, and the stalk of the apple to its right.

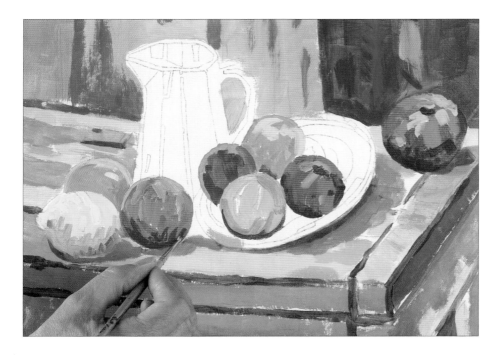

35 Continue painting dark shading under some of the fruit with the same mix.

36 Paint the shine on the apple at the front of the plate with lemon yellow, white and a tiny bit of burnt sienna.

37 Use the medium flat brush and white with a tiny hint of orange to paint the left-hand side of the jug, then change to the small round brush to paint the plate and the highlight down the middle of the jug.

38 Add cobalt blue and alizarin crimson to the white and use the medium flat brush to stroke this pale blue-grey down the jug.

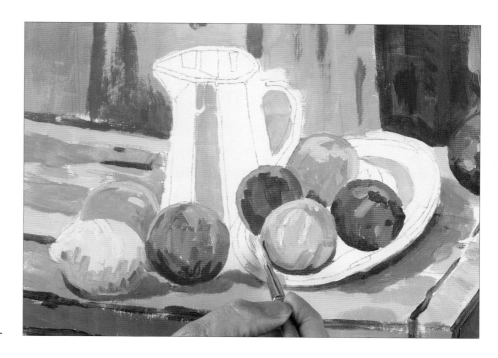

39 Paint the shadow in the plate with the same mix.

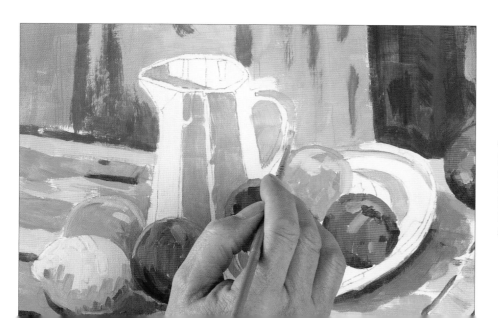

40 Add a little cobalt blue to the mix and paint a band of this colour down the jug with the large flat brush. Paint the shadow inside the lip of the jug and the handle with the same mix on the small flat brush.

41 Add more cobalt blue and paint the right-hand side of the jug.

42 Add alizarin crimson to the mix and paint the darker part of the inside of the jug.

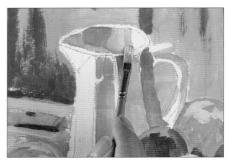

43 Lighten the mix with a little white and paint the lighter part of the inside of the jug.

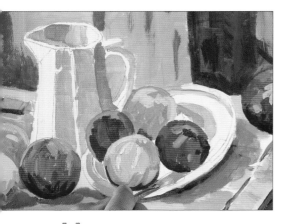

44 Paint the same mix around the shaded parts of the plate.

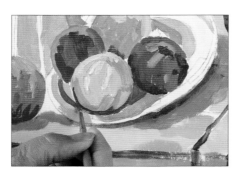

45 Mix cobalt blue and a little white and use the small round brush to paint the darkest parts of the plate.

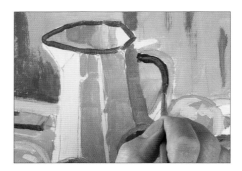

46 Paint the rim of the jug and the inside of the handle with the same mix.

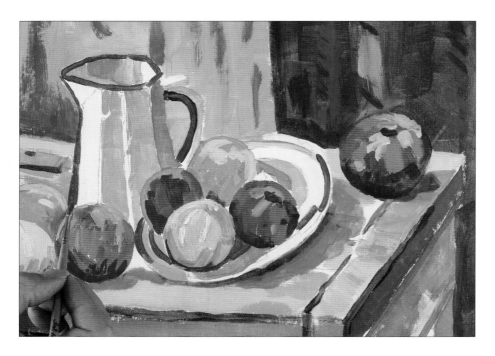

47 Use the same mix and brush to paint the left-hand side of the jug.

48 Make a dark mix of burnt sienna and cobalt blue and paint this in the deeply shadowed area beneath the plate and the fruit.

49 Paint a dark line of the same colour beneath the apple on the far right, and add an indentation in the apple at the front of the plate.

50 Add the shadow between the lemon and the apple with the same dark mix.

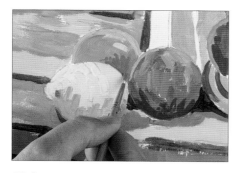

51 Mix Hooker's green, lemon yellow and a touch of cadmium orange and white and paint the darker shadow on the green apple behind the lemon.

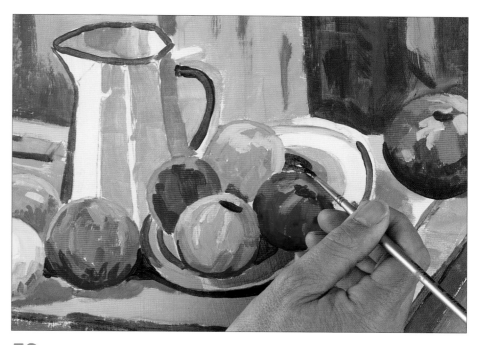

52 Paint the dark shadow at the back of the plate with cobalt blue and burnt sienna.

53 Add a touch of the same dark shadow between the fruit.

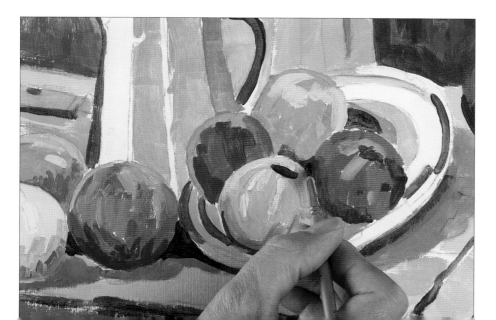

Overleaf

The finished painting.

61

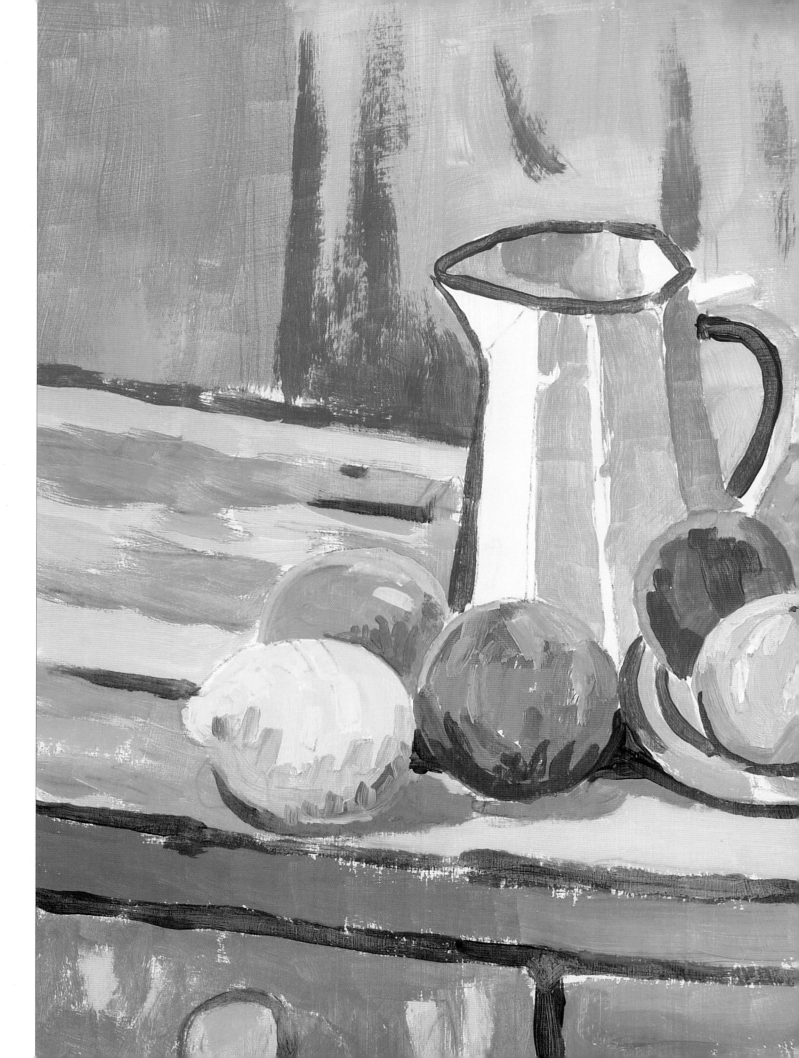

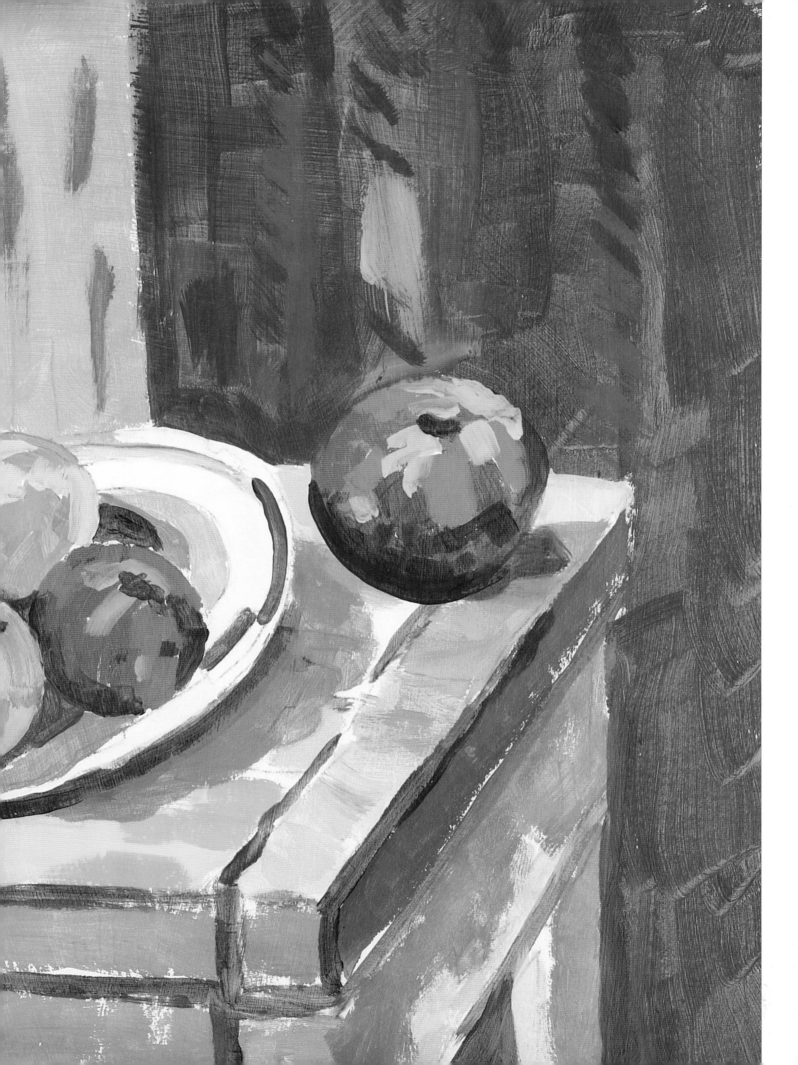

Index

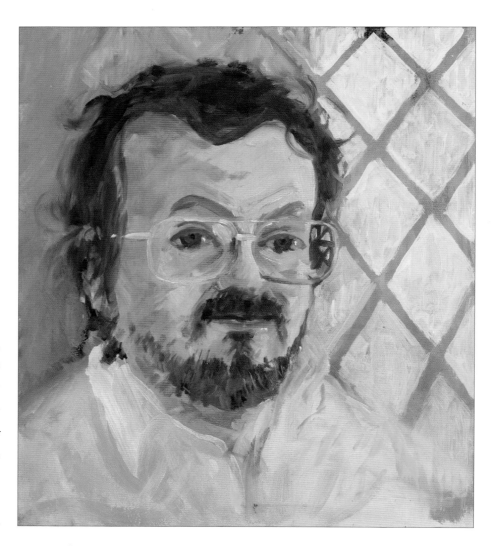

Self Portrait of the Author

33.5 x 38cm (13¼ x 14¼in)

Cézanne always painted himself in the same semi-profile pose; often with an intense expression. My self portrait was done in the style of the one shown on page 7. Painted with large strokes of colour and a large brush, my version was done in front of a window. Reflected light from a terracotta wall falls on one side of the face and external light on the other. I have exaggerated the colour from the wall. The angular brush strokes are allowed to show here and there.

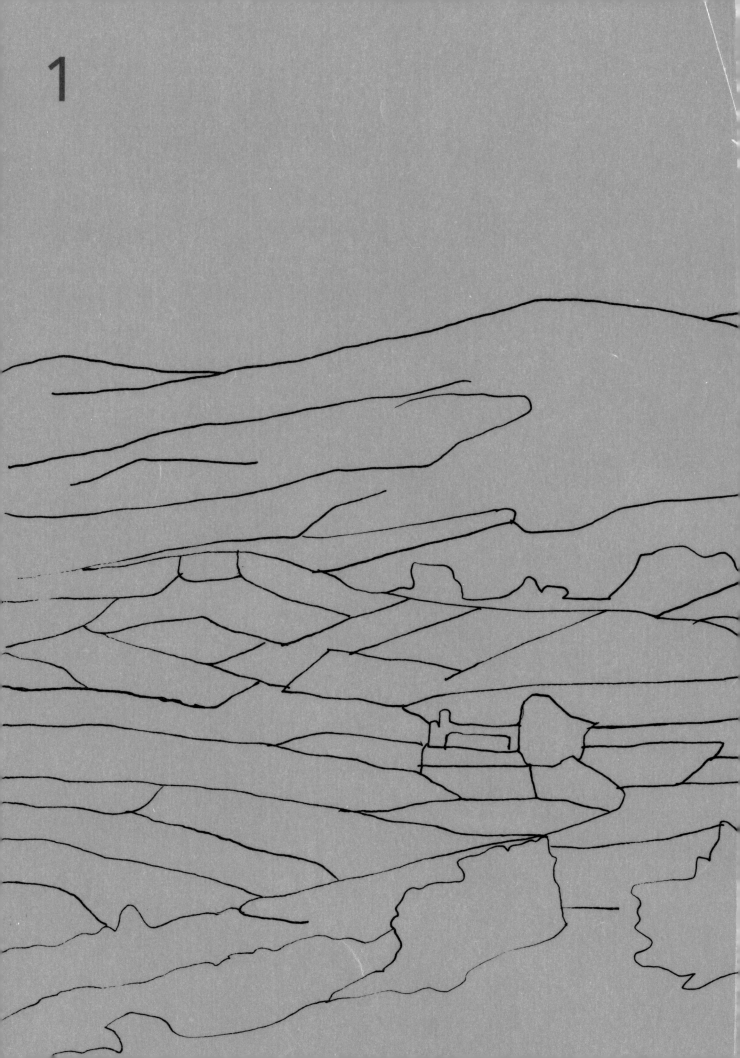

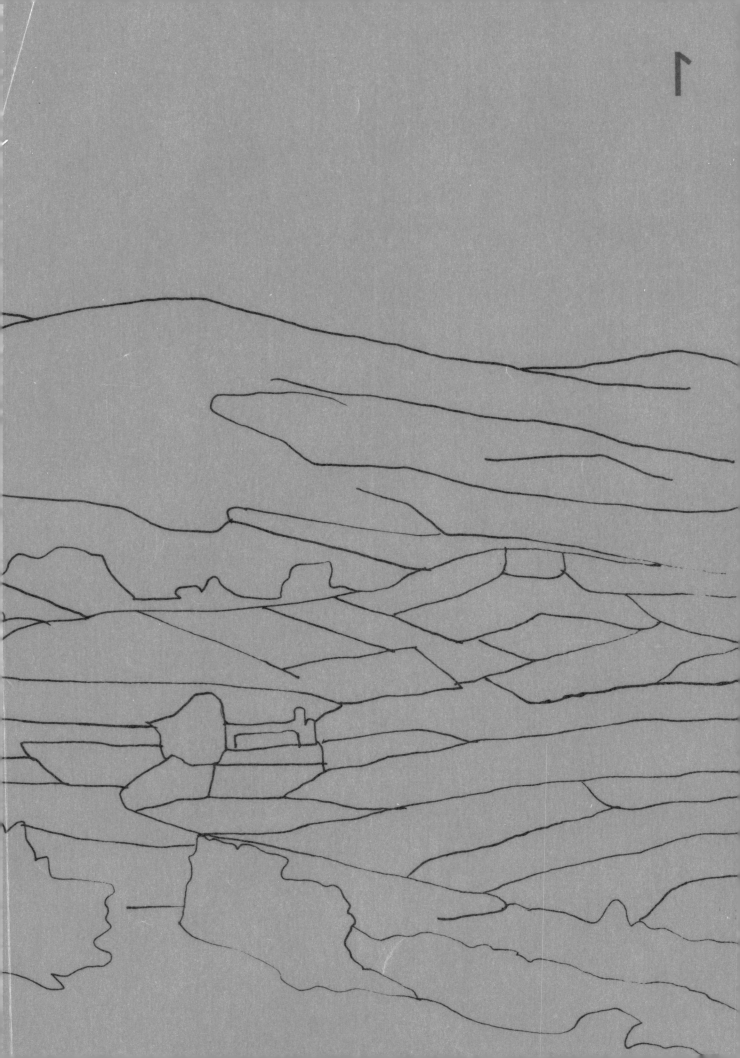

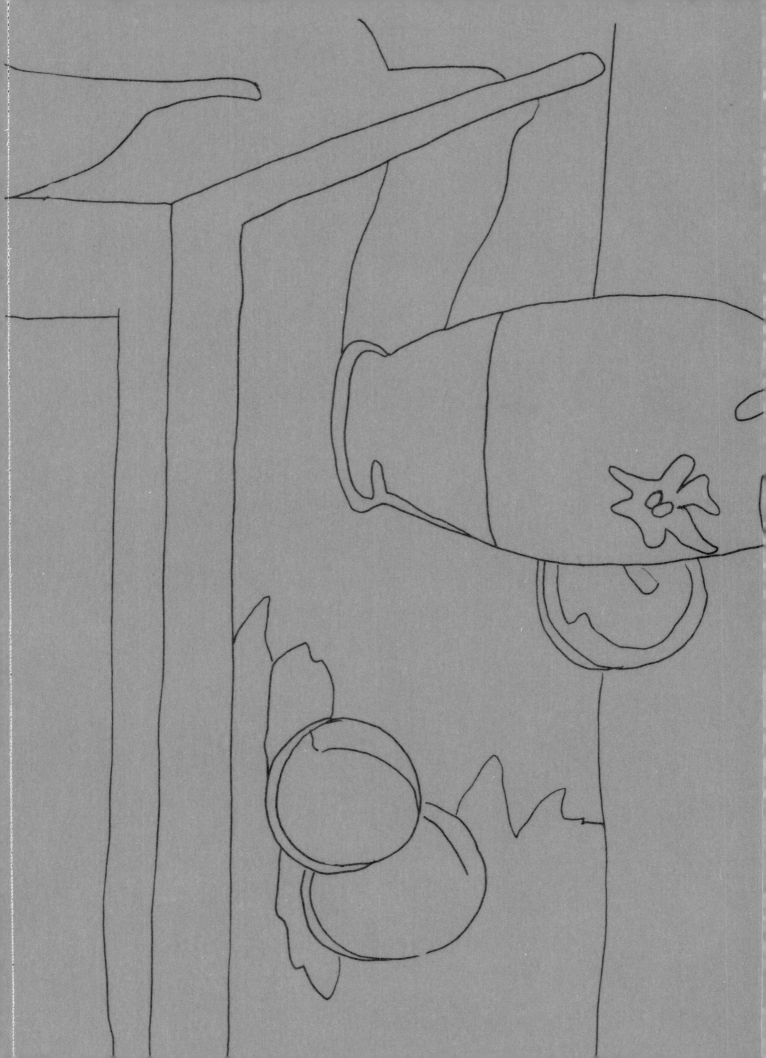

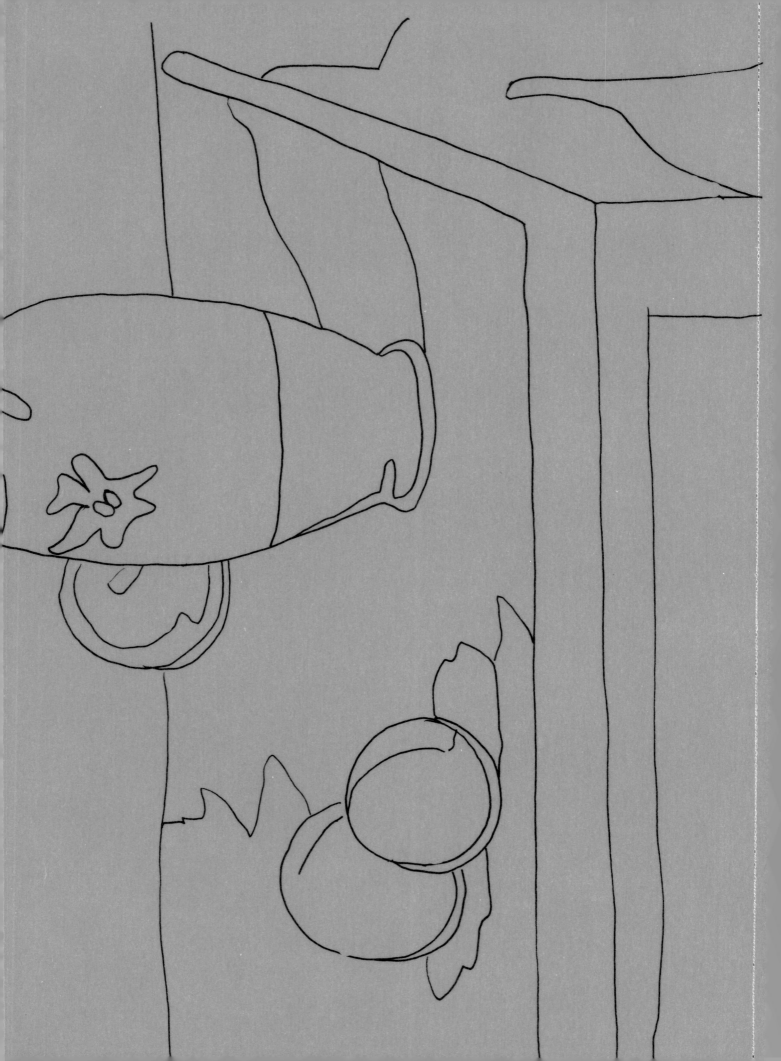

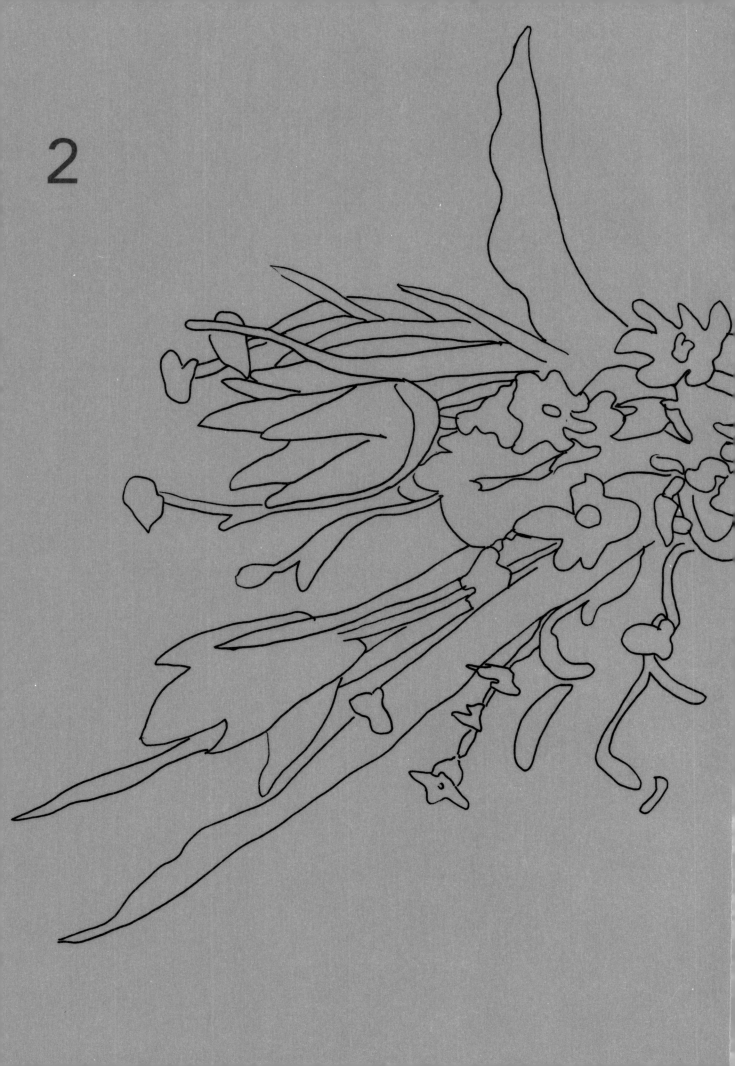

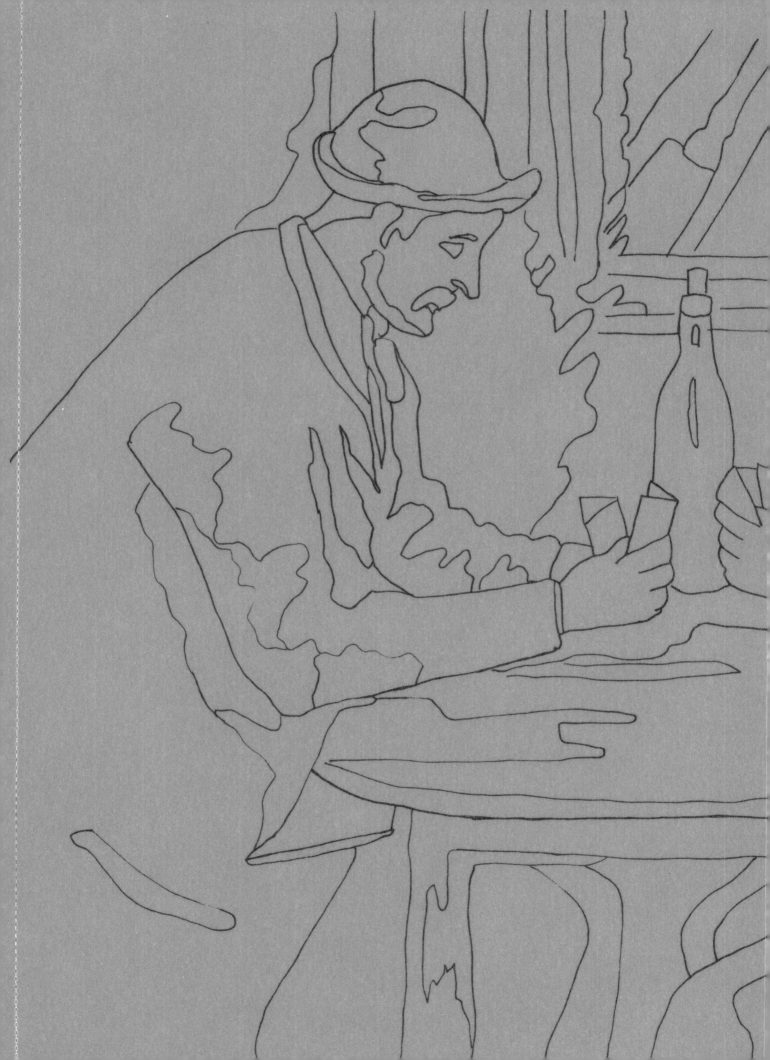

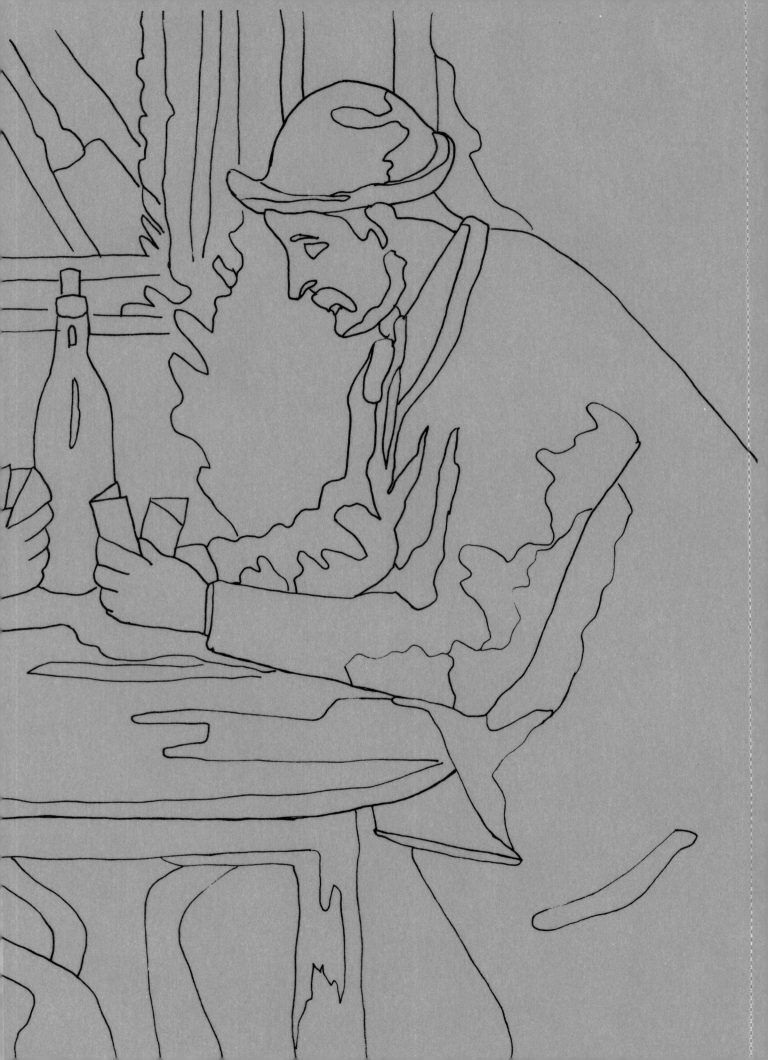

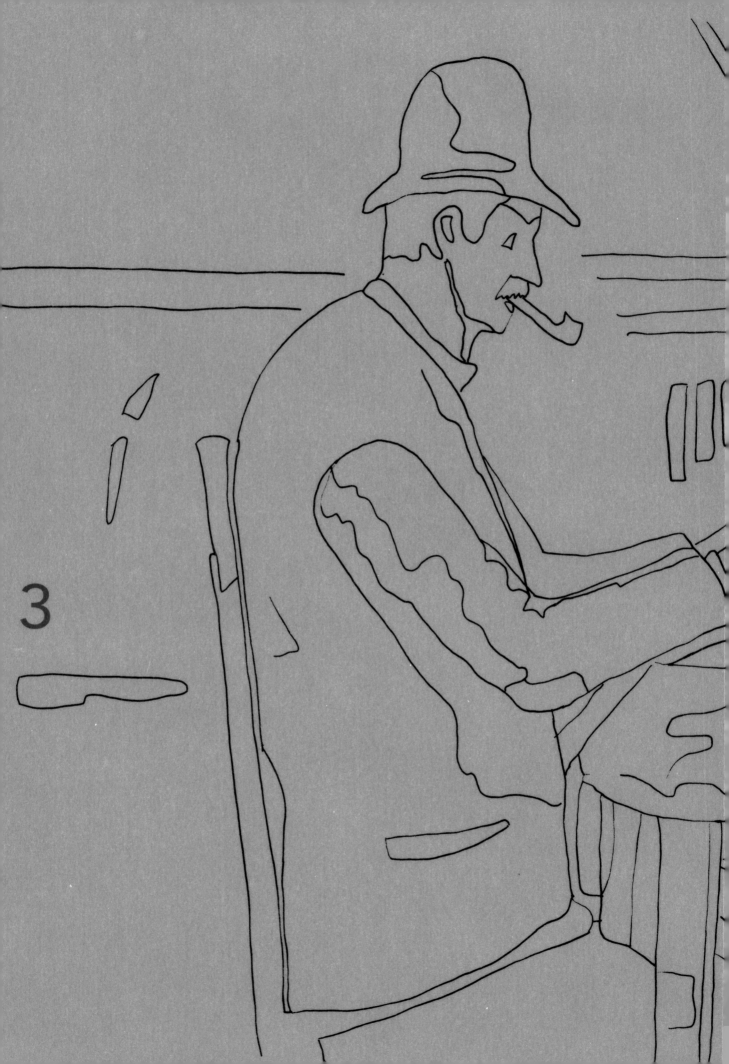

3

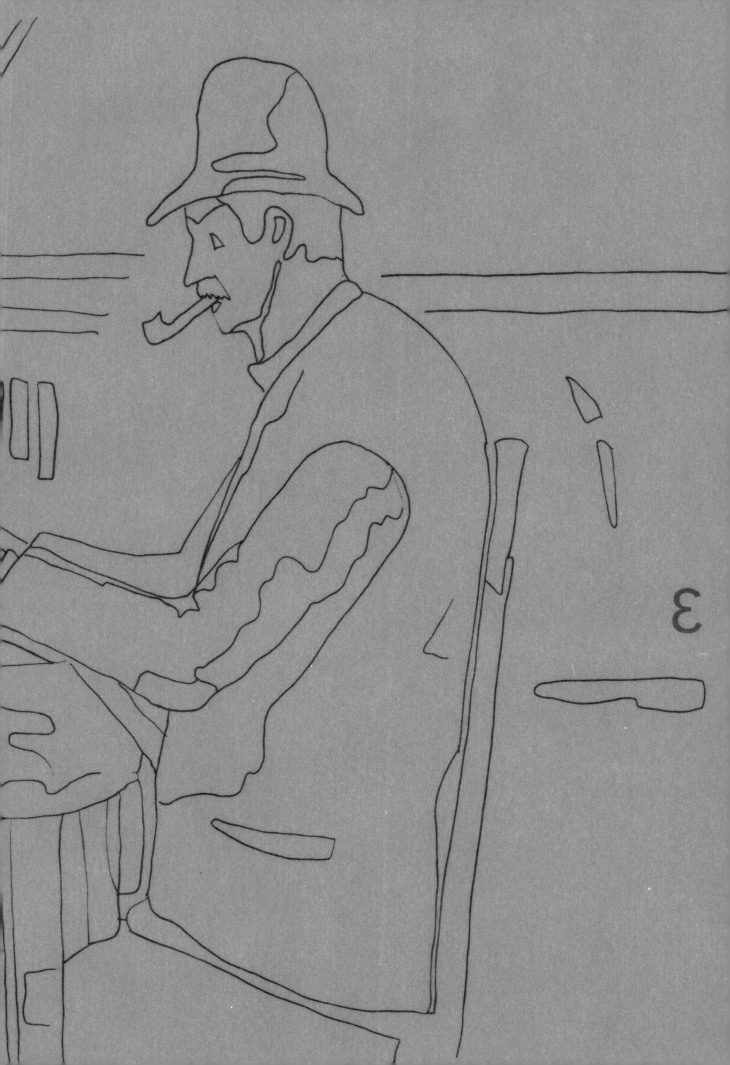

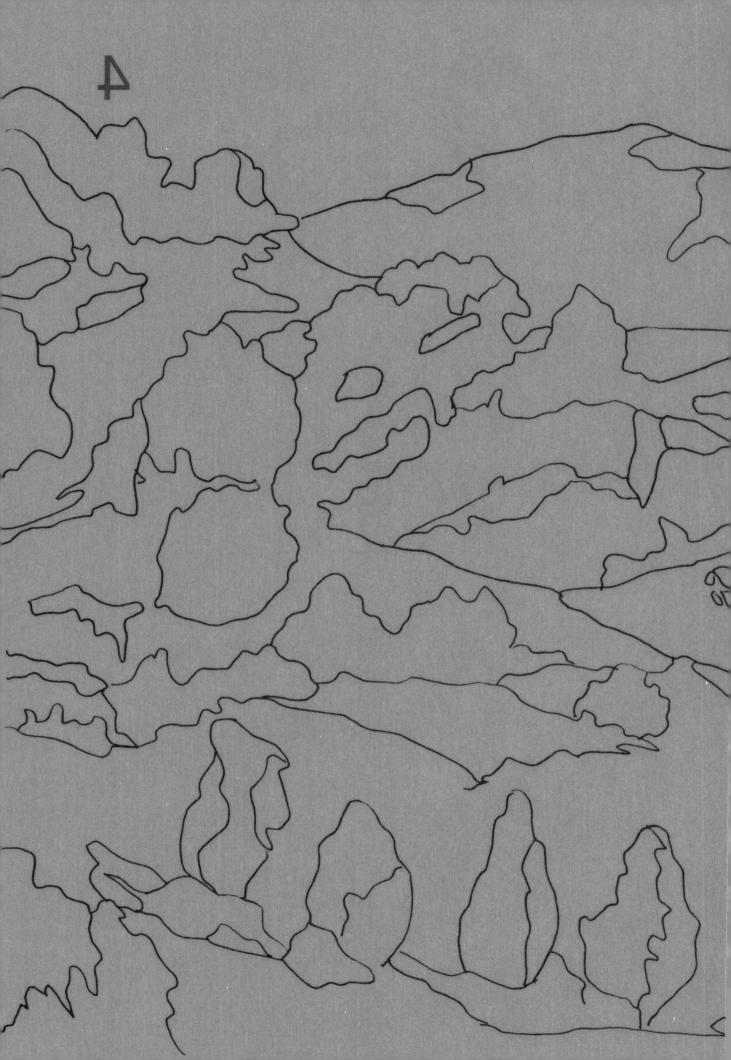

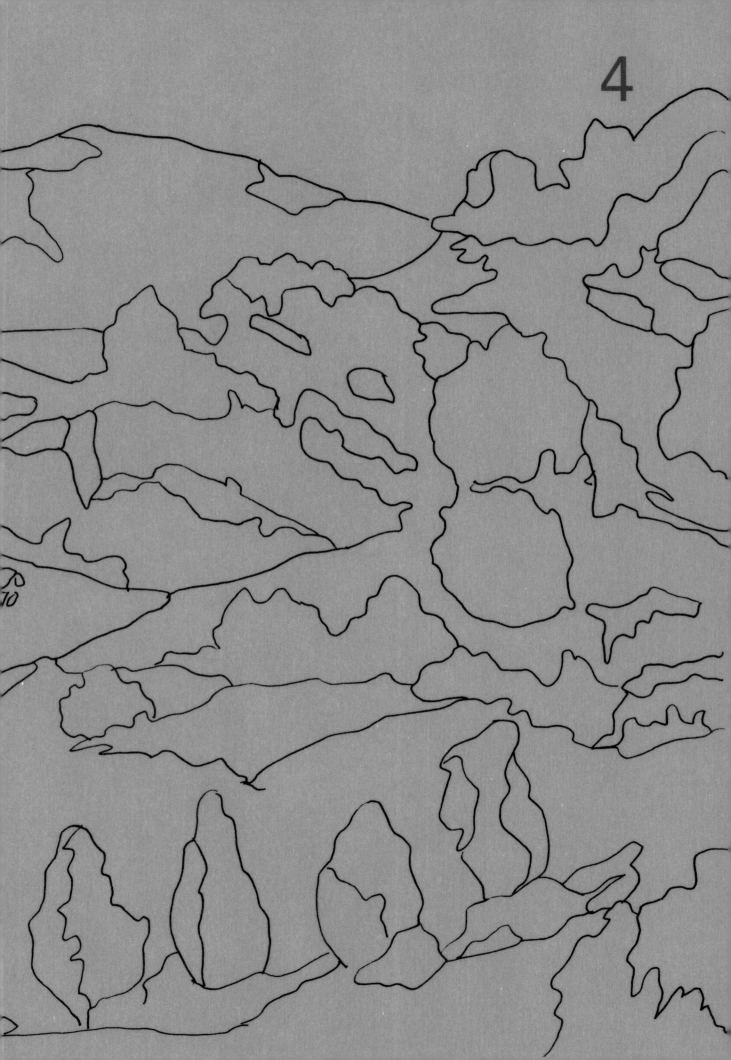

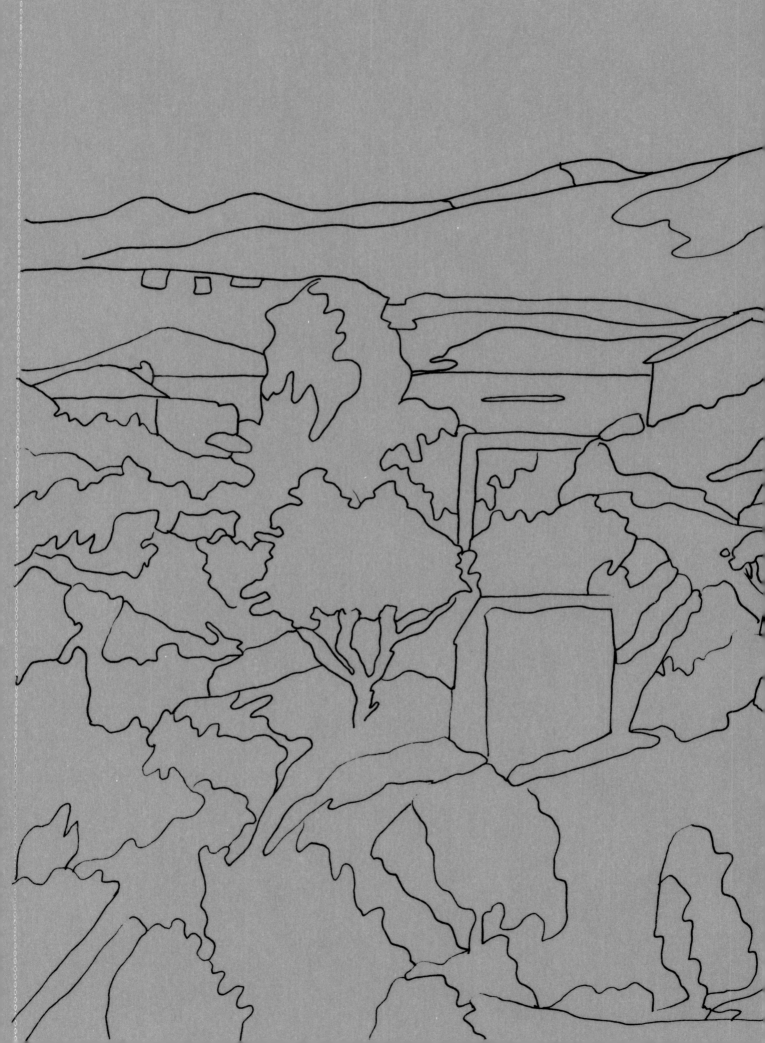

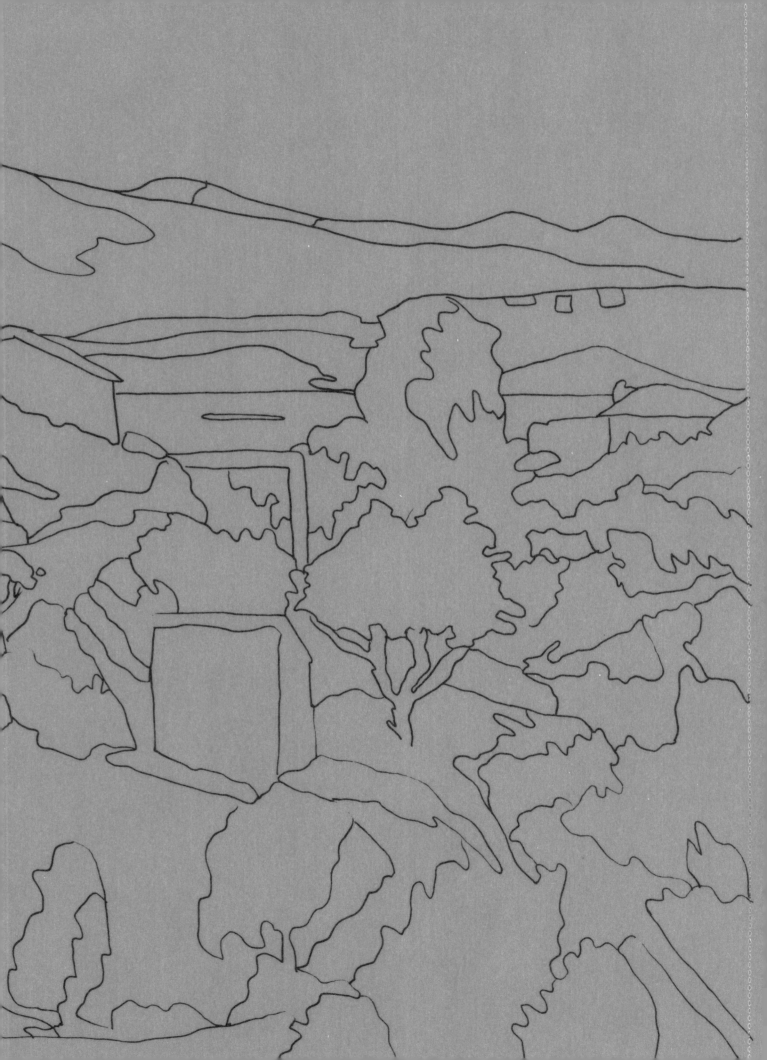

5

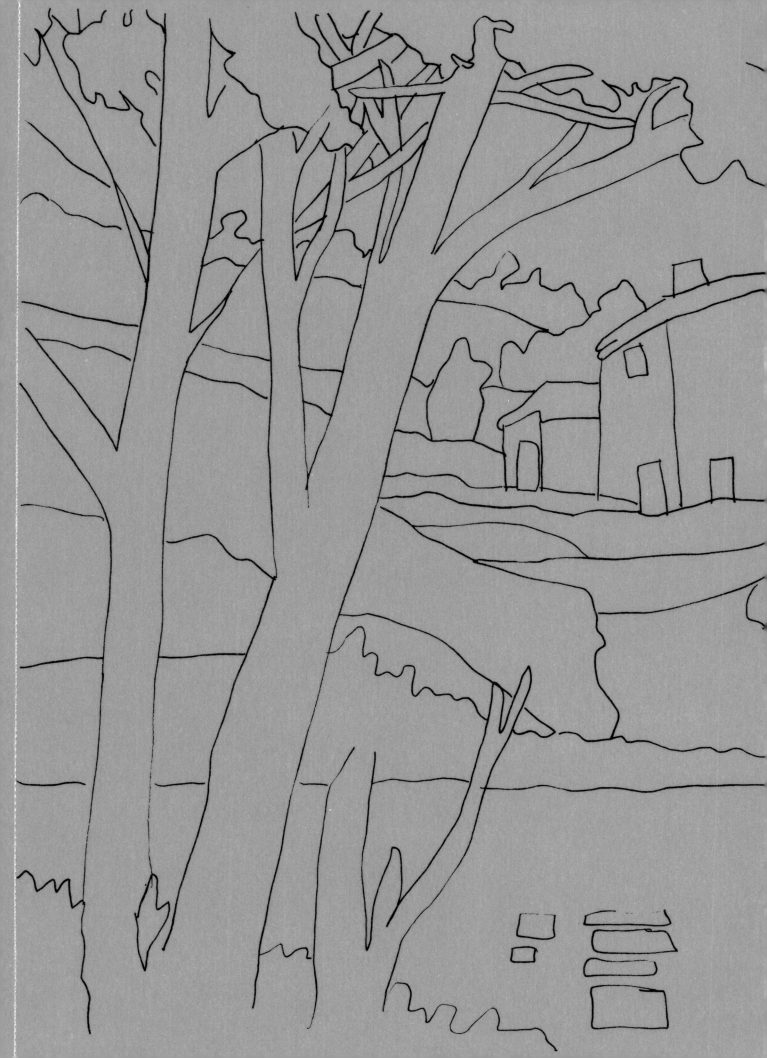

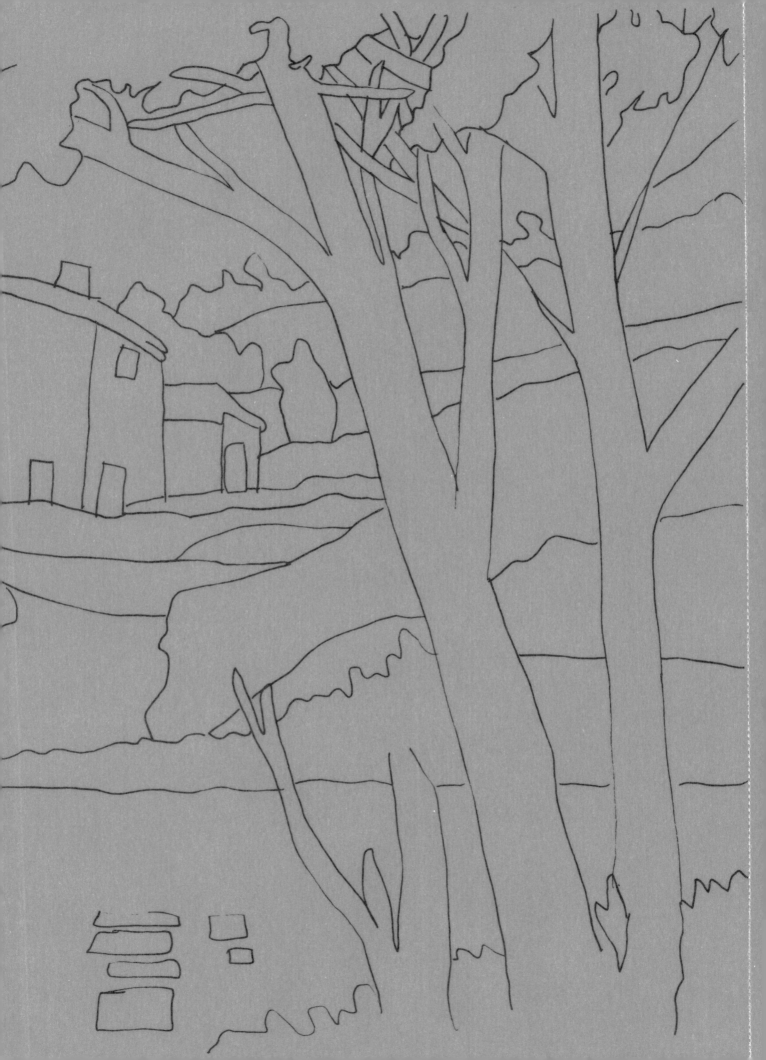

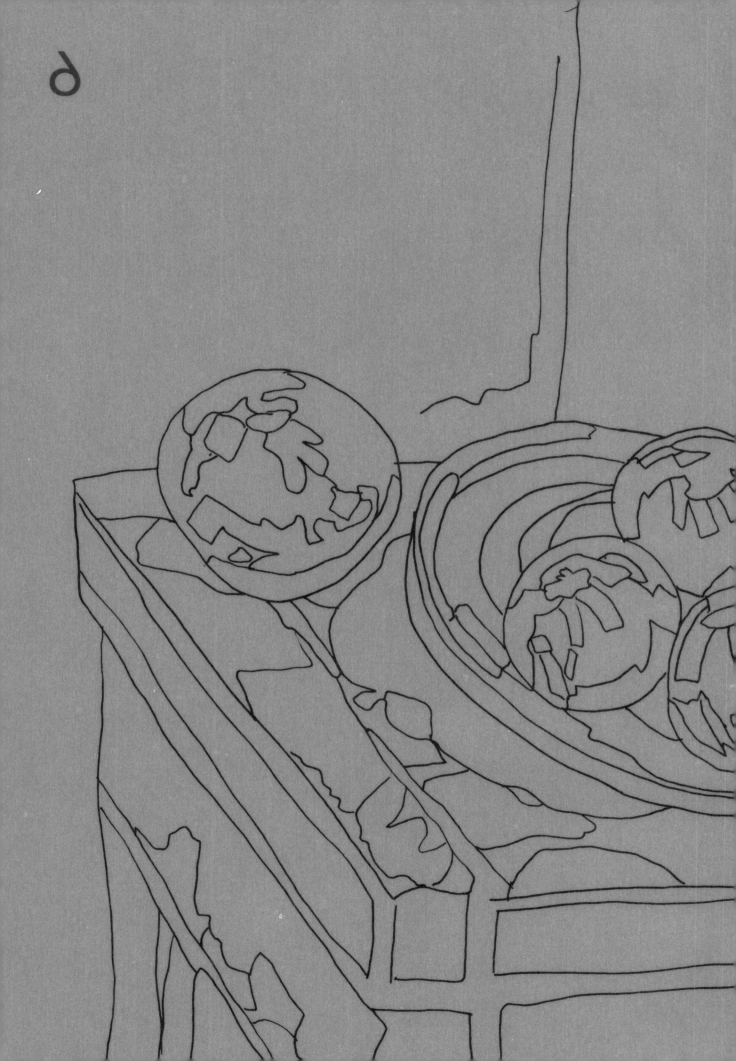

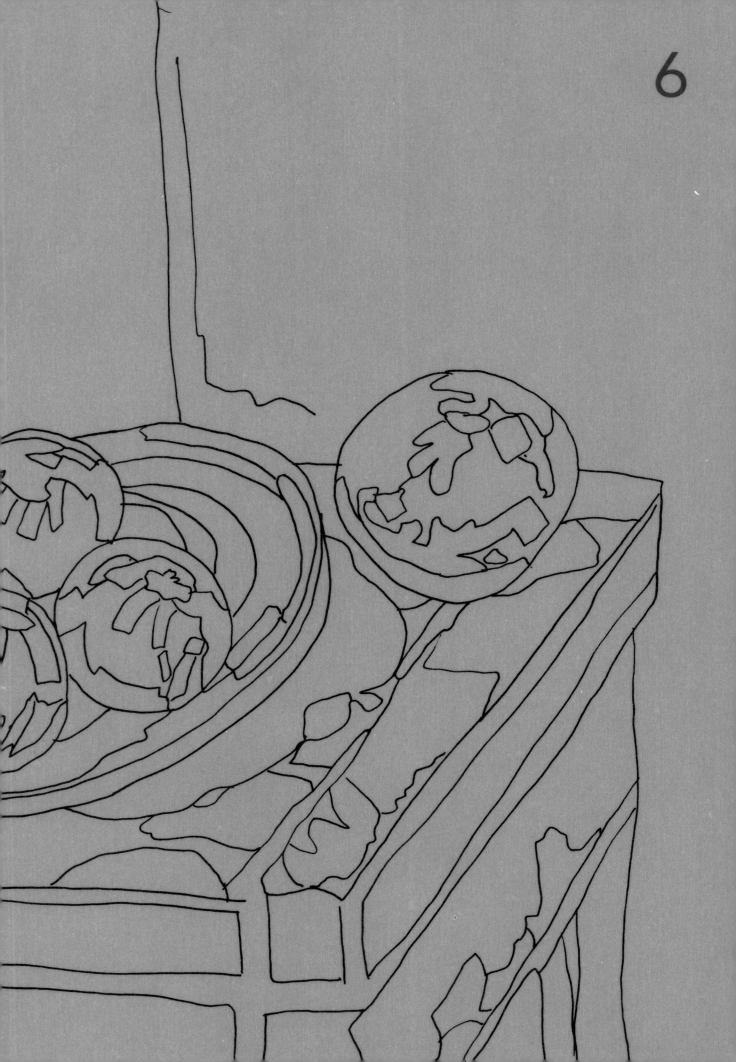

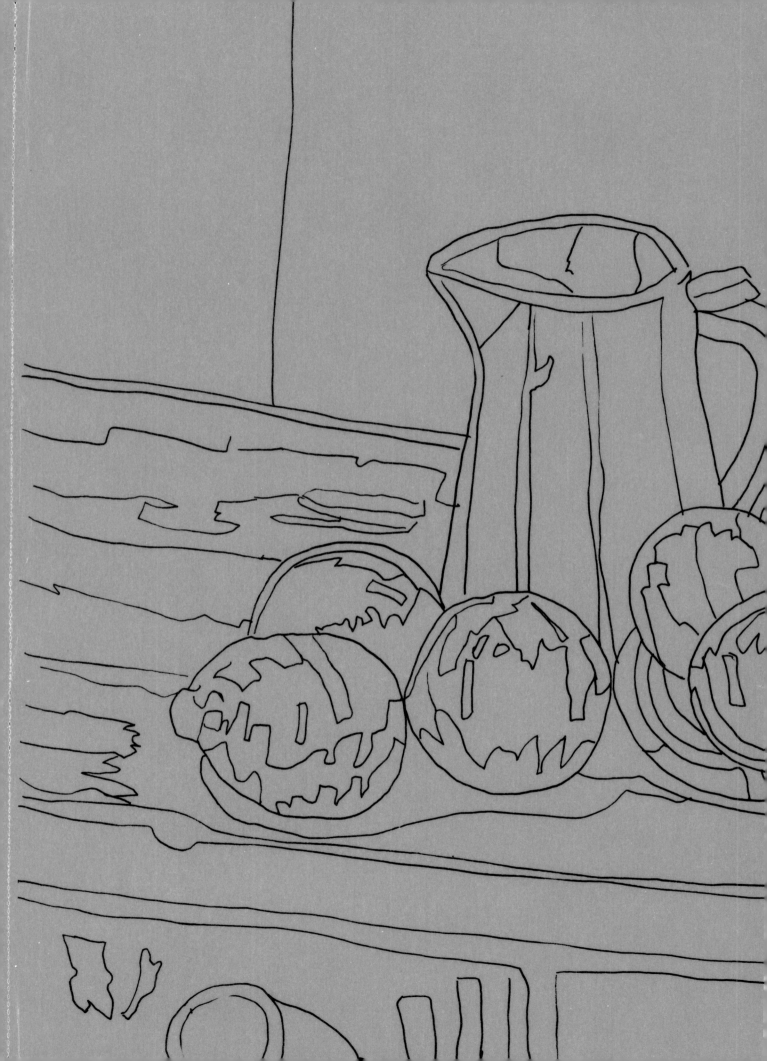

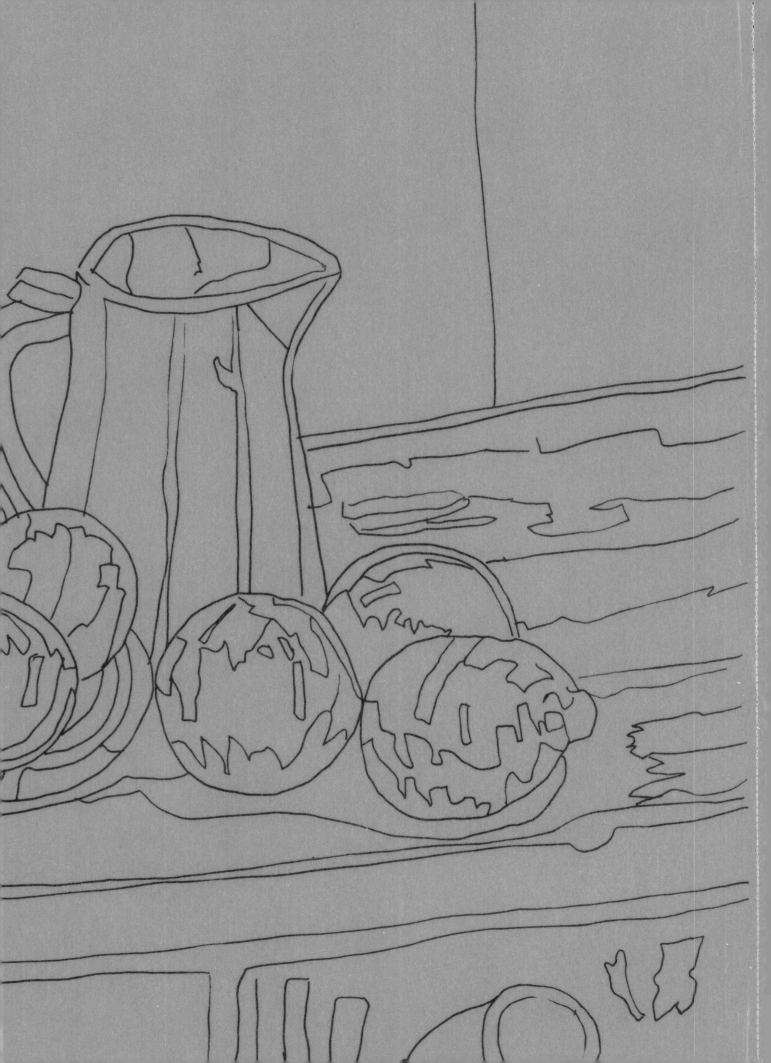